# HOW TO

# Airbrush T-Shirts

## AND OTHER CLOTHING

# HOW TO

# Airbrush T-Shirts

## AND OTHER CLOTHING

DIANA MARTIN AND ED WHITE

**NORTH LIGHT BOOKS**

Cincinnati, Ohio

Permissions

All step-by-step demonstrations and illustration artwork by Ed White, unless otherwise noted below.

Don Ashwood: pp. 64, 65 (left), 68 (top), 69 (top left, right), 70 (top right), 106 © Don Ashwood. All Rights Reserved. Used by permission.

Steve Burrows: pp. 65 (right), 67 (bottom left), 71 (top right), 103 (top) © Steve Burrows. Used by permission.

Rich Champagne: pp. 70 (top left), 99 (bottom right), 100 (right), 101 (left) © Rich Champagne. Used by permission.

Rich Hernandez: pp. 63 (right), 71 (bottom right), 96, 99 (left, top right) © Rich Hernandez. Used by permission.

Terry Hill: pp. 62, 63 (left), 68 (bottom), 71 (left), 104 (bottom) © 1993 Terry Hill, Hot Air. All Rights Reserved. Used by permission.

Rick "Rix" Kordsmeier: pp. 67 (right), 69 (bottom left), 102, 103 (bottom) © Rick Kordsmeier. Used by permission.

Joan Sanders: pp. 67 (top left), 70 (bottom), 98 (right), 104 (top), 107 © Joan Sanders & Rich Champagne, Airresistible. Used by permission.

98  97  96  95  5  4  3  2

**Library of Congress Cataloging-in-Publication Data**

Martin, Diana.
    How to airbrush T-shirts and other clothing / Diana Martin and Ed White.
       p. cm.
    Includes index.
    ISBN 0-89134-570-1
    1. Textile painting. 2. Airbrush art. 3. Stencil work. 4. T-shirts. 5. Wearable art. I. White, Ed (Edward). II. Title.
TT851.M37 1994
746.6—dc20
                                        94-5640
                                        CIP

Edited by Perri Weinberg-Schenker
Interior design by Brian Roeth
Cover design by Brian Roeth
Cover illustrations by Ed White
Step-by-step photography by Diana Martin

| METRIC CONVERSION CHART | | |
|---|---|---|
| **TO CONVERT** | **TO** | **MULTIPLY BY** |
| Inches | Centimeters | 2.54 |
| Centimeters | Inches | 0.4 |
| Feet | Centimeters | 30.5 |
| Centimeters | Feet | 0.03 |
| Yards | Meters | 0.9 |
| Meters | Yards | 1.1 |
| Sq. Inches | Sq. Centimeters | 6.45 |
| Sq. Centimeters | Sq. Inches | 0.16 |
| Sq. Feet | Sq. Meters | 0.09 |
| Sq. Meters | Sq. Feet | 10.8 |
| Sq. Yards | Sq. Meters | 0.8 |
| Sq. Meters | Sq. Yards | 1.2 |
| Pounds | Kilograms | 0.45 |
| Kilograms | Pounds | 2.2 |
| Ounces | Grams | 28.4 |
| Grams | Ounces | 0.04 |

**Dedication**    To Bobino, who adds a double rainbow of color to my life.

To my family: Mom, Dad, Jess, Kim, Jean and Steve, and especially to Tammy and Bobby, without whom this wouldn't matter.

**Acknowledgments**    Special thanks go to the Antonelli Institute of Art and Photography, which let us use studio time and equipment to photograph the step-by-step demonstrations; to Robert Porco, who lent his creative eye to photo styling for much of the portfolio photography; to artists Don Ashwood, Steve Burrows, Rich Champagne, Rich Hernandez, Terry Hill, Joan Sanders and Rick Kordsmeier, who generously took time from their hectic businesses to create illustrations for the book; and to Dan White at Oz Graffix who donated the T-shirts used in the demonstrations.

# TABLE OF CONTENTS

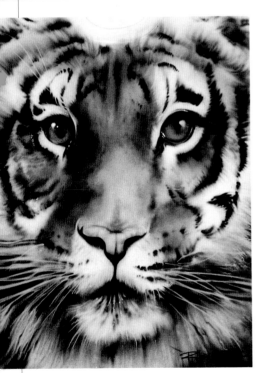

*Chapter 1*
What you need to know to get started in T-shirt art, including:
- equipment and materials
- special effects techniques
- working with different fabrics
- how to sell your work

*Chapter 2*
Takes you through the process of designing, cutting and using stencils, including:
- stencil materials
- positive and negative stencils
- spraying with stencils

*Chapter 3*
Step-by-step demonstrations show you how to use stencils to create popular designs. Learn how to:
- do lettering and illustrations
- handle multiple stencils
- create highlights and detail

**Demonstrations**

Airbrushing Shape, Shading and Highlight—Using Overspray to Blend Colors—Gradating Color to Create a 3-D Effect—Airbrushing Stenciled Script Lettering—Rendering Dimension and Form—Working With Intricate Stencils—Combining Lettering and Illustration—Airbrushing Detail, Flesh Tones and Drop Shadows—Using Multiple Stencils—Combining Multiple Lettering Styles

**Professional Portfolio**

**Demonstrations**

Rendering Block Lettering—Freehanding Script Lettering—Freehanding Spike Lettering—Rendering a Complete Script Name—Combining Script, Brush and Block Lettering—Airbrushing an Illustration on Canvas—Combining Multiple Lettering Styles and Illustration—Airbrushing on Black Fabric

**Professional Portfolio**

## About the Authors

Ed White is a freelance illustrator based in South Point, Ohio, whose artworks include T-shirt and commercial illustration, murals, signage and auotomotive painting. Born into a creative family, he began drawing early in life and later studied visual communications and fine art, earning a degree in commerical art. Between educational pursuits, he joined the Navy where he completed the Naval Nuclear Power School. He has been a professional T-shirt artist since 1985, and has worked as an art director for a chain of T-shirt shops, owner of a screen printing shop, and an instructor of aspiring airbrush artists.

Diana Martin is a freelance writer and editor based in Cincinnati. She is the co-author of *Getting Started in Airbrush* and *Fresh Ideas in Letterhead and Business Card Design*. Prior to freelancing full-time, she was senior editor of graphic design books for an international publisher for whom she developed and edited ten books and workbooks on airbrushing. She also has worked as an award-winning staff photojournalist on a number of daily papers.

# INTRODUCTION

The world of T-shirt illustration is one of imagination.

Imagine being able to airbrush any subject—lovers, animals, sunsets, rock stars, cartoons or lettering—onto a plain, white T-shirt, and turn it into wearable art.

Imagine being able to produce a colorful, dramatic or wacky T-shirt image in less than fifteen minutes.

Imagine making a part- or full-time living doing just T-shirt illustration.

Imagine opening your own airbrushing business, in a shopping mall, on a beach boardwalk, or in your own studio.

Imagine walking down the sidewalk and seeing someone wearing one of your airbrushed images.

Hundreds of professional T-shirt artists around the country do more than just imagine these experiences; they live them, every day, year round, while having successful (and profitable) careers.

As a beginner, you, too, can aspire to become a successful amateur or professional T-shirt artist. And this book will teach you everything you need to know to do just that: How to get started and how to make a living, if that's your goal. It's true that many airbrush artists are self-taught, but why go that route when you can learn from the experiences of other, established, artists? In *How to Airbrush T-Shirts and Other Clothing* you will find the professional tricks, techniques and tips that you need to get started and to succeed.

We have three pieces of advice. The first is to take full advantage of the pictures *and* the words you'll find on every page. Sure, the pictures are more fun because they show the step-by-step creative process. But the information in the text and the captions is just as important, because we guarantee that they will put you ahead of other beginners. You'll discover which basic techniques you *must* master, shortcuts that will save you time and money, and sound business practices that will give you the savvy usually acquired after years of painting.

Our second piece of advice makes beginners in any field groan: You have to practice. Mastery comes only from practice and from knowing how your airbrush works, how to spray the essential strokes, and how paint reacts to fabric.

Finally, the third piece of advice is simple: Have fun. There's nothing like turning an ordinary T-shirt into a wild, sophisticated or funky piece of art, and hearing the verbal applause of customers who *can't* imagine how you did it.

## Contributing Artists

**Don Ashwood** (Hot Air, Fort Walton Beach, Florida) has been airbrushing for sixteen years, starting at the age of fourteen. During those early years, he set up in his backyard, and painted six hours a day, learning his craft. Raised in Fort Walton Beach, Ashwood was inspired early on by the abundant airbrushing talent in that area. After five years in the business, he met and taught airbrushing to his now-partner, Terry Hill. Ashwood's work has appeared on the inside and the cover of *Airbrush Action* magazine.

Technical Stats

*Airbrushes:* Uses twenty Thayer and Chandler Vega 2,000 airbrushes.
*Paint:* Createx.
*Air source:* Jun-Air Maxi air compressor.
*Painting surfaces:* T-shirts and CS10 illustration board.
*Stencil material:* Posterboard and X-ray film.
*Sketching medium:* Ebony pencil.
*Number of stock designs:* Over 100.
*Time on the brush/year:* Six months (eighty hours/week).
*Production:* Stock designs comprise 90 percent of production.

**Steve Burrows** (Fort Walton Beach, Florida) has always liked to draw, but did not consider a career in art until his sophomore year in college, when he fully discovered his drawing abilities. At the same time, Burrows began studying airbrush with a friend and professional T-shirt artist. He worked the next three summers painting T-shirts in Fort Walton Beach before graduating with a bachelors degree in communication graphics and returning to Fort Walton Beach to continue his career.

Technical Stats

*Airbrushes:* Uses twelve Paasche VL3 and three Thayer and Chandler Vega 2,000 airbrushes.
*Paints:* Createx, Versetex Blue and Aqua Flow Red Brown.

*Air source:* Sears 1 horsepower air compressor (8-gallon air tank).
*Painting surfaces:* Pellon, sand dollars, car tags and T-shirts.
*Stencil material:* Posterboard and wax paper.
*Sketching medium:* Vine charcoal and white chalk.
*Number of stock designs:* Over seventy-five.
*Time on the brush/year:* Seven months.
*Production:* Produces over 3,000 stock designs during his seven-month season, including over 100 sand dollars and 200 car tags. His off-season work includes murals, custom paintings and illustrations, and screenprint illustrations.

**Rich Champagne** (Airresistible, Muncie, Indiana) began airbrush painting in Louisiana after dropping out of a college where modern and impressionistic art were the styles being taught. After working the fair circuit, Champagne moved to Panama City, Florida, where he painted for six years. During that time he became an instructor for the Airbrush Action Getaways, where he met his current partner, Joan Sanders. When the market in Panama City slowed down, Champagne moved to Muncie, Indiana, where he and Sanders opened Airresistible, an airbrushing shop. Champagne is currently moving out of the T-shirt market and into commercial illustration.

Technical Stats

*Airbrush:* Paasche VL3.
*Paint:* Dr.Ph.Martin Ready Tex.
*Air source:* Craftsman 1 horsepower compressor (8-gallon air tank).
*Painting surfaces:* Mostly 50-50 blend T-shirts.
*Stencil material:* Posterboard.
*Sketching medium:* 4B, 6B or Ebony pencils.
*Number of stock designs:* One hundred.
*Time on the brush/year:* Works year round.
*Production:* 1,000 to 1,250 stock designs per year.

**Rich Hernandez** (Living Color Designs, Panama City, Florida) started air-

brushing in 1980 in Panama City, Florida, one of the hottest beach T-shirt scenes in this country. He describes himself as "very lucky to have started there because of the many talented people I've worked with." Hernandez's favorite airbrush-related task is designing his T-shirt displays, for which he is well-known.

Technical Stats

*Airbrushes:* Iwata HPC, Paasche VL3.

*Paints:* Aqua Flow, Dr.Ph.Martin.

*Air sources:* Air compressors, 5 horsepower and 1 horsepower.

*Painting surfaces:* Cotton T-shirts (50-50 blend and 100 percent) and CS-10 illustration board.

*Stencil materials:* Posterboard and frisket film.

*Sketching medium:* Nonrepro blue pencil and Ebony pencil.

*Number of stock designs:* Over 250.

*Time on the brush/year:* Works year round.

*Production:* During summer season, one hundred to two hundred shirts per day; off-season, ten to fifty per day.

**Terry Hill** (Hot Air, Fort Walton Beach, Florida), a well-known, professional airbrush artist, began his adult career as a welder for an aircraft company, quickly moving up into management. A major company layoff ended that career, but set him up to meet his partner Don Ashwood, from whom Hill learned the art of the airbrush and with whom he has been partners for twelve years. Hill teaches regularly at the Airbrush Action Getaways and develops airbrush products with various companies.

Technical Stats

*Airbrushes:* Twenty Thayer and Chandler Vega 2,000 and one Iwata HPBC-2 airbrushes.

*Paint:* Createx.

*Air source:* Sil-Air 50 - 24 1/2 horsepower silent compressor (the Terry Hill model).

*Painting surfaces:* Cotton T-shirts (100 percent and 50-50 blend).

*Stencil material:* High-impact polystyrene, X-ray film and posterboard.

*Sketching medium:* 6B Ebony pencil.

*Number of stock designs:* Over one hundred.

*Time on the brush/year:* Six to eight months.

*Production:* 90 percent of production are stock designs.

**Rick "Rix" Kordsmeier** (Rix Air Grafix, Kalispell, Montana) began airbrushing in 1989 and today owns his own T-shirt shop. A former police officer and restaurateur, Kordsmeier was attracted to the airbrush after watching a friend use the tool to paint a wall mural. After six months of nearly non-stop practice in his bedroom, he landed a job in a T-shirt shop in Louisiana. He opened his own shop in 1993 in Montana, an area where airbrushing is a growing business catering to visiting skiers and tourists traveling to nearby Glacier National Park. After only four months in business, Kordsmeier moved from a shop with 264 square feet to one with 1,000 square feet. He tripled his business, now producing three hundred to five hundred T-shirts a day.

Technical Stats

*Airbrushes:* Twelve Paasche brushes.

*Paints:* Aqua Flow and Createx.

*Air sources:* Sears Air Compressor, 1 1/2 horsepower (8-gallon air tank).

*Painting surfaces:* T-shirts and car license plates, in addition to computer graphics and portraits, and T-shirt transfers.

*Stencil material:* Pellon.

*Number of stock designs:* 150 to 200.

*Time on the brush/year:* Works year round.

*Production:* Over six thousand items/year.

**Joan Sanders** (Airresistible, Muncie, Indiana) experienced T-shirt airbrushing for the first time during a senior high school trip to Florida. She was hooked and received an airbrush from her parents for high school graduation. While in college, Sanders painted T-shirts during summer breaks at her grandparents' business, the Mt. Lawn Speedway, in New Castle, Indiana. Armed with an undergraduate degree in graphic design and a masters degree in printmaking, Sanders attended an Airbrush Action Getaway, where she studied with T-shirt artist Rich Champagne, with whom she now runs a T-shirt shop in Muncie, Indiana.

Technical Stats

*Airbrush:* Paasche VL3.

*Paints:* Createx and Dr.Ph.Martin Ready Tex.

*Air source:* Craftsman 1 horsepower compressor (8-gallon air tank).

*Painting surfaces:* T-shirts, license plates, leather, canvas, mirrors, wood, posterboard, tennis shoes, hats, illustration board, you name it!

*Stencil material:* Posterboard.

*Sketching medium:* 4B or 6B pencil.

*Number of stock designs:* About one hundred.

*Time on the brush/year:* Works year round.

*Production:* Produces 1,000 to 1,250 stock airbrush illustrations per year.

# How to Get Started

CHAPTER

## Airbrushing on T-Shirts and Other Fabrics

Airbrushing on T-shirts was the stepchild of the commercial art world. But times and attitudes have changed. Today, custom and mainstream T-shirt illustrations by top artists compete with the best commercial illustration, and the T-shirt business itself is highly profitable, with top artists earning around *a dollar a minute.*

As a beginning T-shirt artist, you face a wonderful, wide-open creative experience. Once you have gained proficiency in airbrushing on T-shirts, you can explore a myriad of other fabrics, garments and objects: denim, canvas, leather, spandex, tote bags, visors, ball caps, sneakers, socks, wall hangings, bodysuits and curtains are a few. And after you airbrush enough fabric gifts for family and friends, you can branch out into producing airbrushed items for customers, making money and, perhaps, making a part- or full-time business from your art.

## How to Find Ideas and Inspiration

Look all around for ideas and inspiration; books, magazines, billboards, ads, toys, greeting cards and even maps are sources of ideas, color schemes, lighting and general visual reference. You can create your own references by shooting photographs of objects or people you want to render. (But don't photograph people without permission—ideally, written permission.) You can also create a clip file in which you organize printed photographs or illustrations that you cut out of magazines or books. A file is especially useful if you cannot photograph an object yourself or when you need inspiration about illustration styles or techniques. Art supply and book stores also carry clip art and pattern books that contain copyright-free artwork.

Be aware, however, of the legalities associated with using other artists' work for ideas or visual reference. Every artist's work is protected by a copyright, which means you cannot copy it and claim it as your own or try to sell it. You can copy it as a practice exercise and use it to inspire your own distinctive rendition of the same object or theme. Watch out, too, for those that are licensed or trademarked, such as Coca-Cola or the National Football League, characters from cartoons, or figures from movies, television shows or books. For example, it's fine for you to capitalize on the popularity of dinosaurs, but you must create your own style of dinosaur—not one that looks like it jumped out of the film *Jurassic Park*.

The T-shirt artist's typical clients include teens and young adults, lovers, families and kids. As you plan your art, keep in mind the kind of imagery popular with these markets: rock musicians, hearts, lovers' names, animals, beach scenes and celebrities

are just a few. Trends can also dictate what is popular.

## Turning Your Ideas Into Sketches

You can choose any of the techniques below to turn an idea into a sketch. Use these techniques whether you are sketching at the size you plan to airbrush or at sizes larger or smaller, which you then can reduce or enlarge using a photocopier. The advantage of having a sketch stage before you transfer an image to stencil or to T-shirt is the opportunity you have to modify the original image.

**1. Tracing technique.** Find a visual reference that is similar to your vision of the final illustration. Tape the reference to a light table or a window using low-tack artist's or masking tape. Tape tracing paper over the reference and trace the image, making creative adjustments as you work. Once the image is transferred you can continue to refine it.

**2. Grid technique.** A grid scales an image either larger or smaller in size. Draw a grid of squares to a consistent size, for example 1-inch square, on tracing paper. Tape this grid over your reference material, such as a photograph or magazine ad, placing both pieces on a light table or a window. Sketch your illustration.

Now, draw another grid to the scale you want to do your final sketch and illustration. If you want to reduce the sketch 50 percent, your second grid would be made up of $1/2$-inch squares; if you want to enlarge the sketch 300 percent, your second grid would be made up of 3-inch squares. Lay this grid over the first one and trace the sketch, transferring common points from grid one to grid two.

**3. Photocopy enlarging.** The capabilities of the modern photocopier seem to increase daily. Although you cannot

photocopy onto your actual painting surface, you can use the enlargement and reduction options to great advantage once you have a basic sketch.

**4. Projection technique.** If your reference is a slide, use a slide projector to transfer and sketch the image onto tracing paper (using a no. 2 pencil), stencil material (using vine charcoal) or a T-shirt (ideally, attached to a shirt-board and also sketched using vine charcoal). The advantage of projecting to tracing paper first, however, is you still have the chance to modify the image if you want.

## Getting Your Idea Onto a Stencil or a T-Shirt

Whether you will airbrush using stencils or freehand, you need to practice and master at least one of the techniques described below for getting your illustration idea onto the stencil or the fabric.

**1. Pouncing.** With this method you poke small holes along the lines of your sketch using a pointed object, such as a stencil burner (see page 28) or an ice pick. Once you have made holes at about $1/2$-inch intervals, spray the back of the drawing with adhesive spray mount (available at art supply stores) and position the drawing on your painting surface. Spray black paint (on a white T-shirt) or white paint (on a black T-shirt) along the drawing lines so that the paint goes through the holes onto the fabric. Remove the sketch, and you are left with a series of dots. Connect the dots, again using black paint for white shirts and white paint for black shirts.

**2. Heat transfer.** You can buy heat transfers or "iron-ons," which are black-and-white line drawings of various subjects, such as cars or popular cartoon characters. Available from air-brush and silkscreen suppliers, trans-

Some artists use soft-lead pencils to sketch drawings onto fabric. Pencils are fine to use if your drawing skills are very strong, but if you want to be able to erase some of your drawn lines, you can use vine charcoal to draw your basic sketch. The ultra-softness of this medium gives you the chance to erase or blow off any misdrawn lines just by spraying air through your airbrush. To erase a line, simply push down on the trigger; do not pull it back or you will release air *and* paint.

Note that you cannot erase lines once you have sprayed over them, so avoid drawing lines (with any lead medium) in areas where you plan to apply light color. The transparency of light-colored fabric paint will let the lines show through. If this does happen, you can cover the offending line by placing a white highlight over it or adding a dark-toned accent.

fers are applied using a heat press, after which you simply airbrush on your colors. To have an original sketch made into a heat transfer, contact a local screen printing shop.

**3. Transfer paper.** Transfer paper is useful for transferring a sketch onto stencil material. You can buy graphite-coated transfer paper at art supply stores or make your own by rubbing the side of a soft-lead pencil on the back of a piece of tracing paper. Place the graphite-coated side against your stencil surface, and place your sketch on top of the transfer paper. Retrace the sketch using a hard-lead, no. 2 pencil or a ballpoint pen. The pencil's pressure transfers the graphite onto the stencil, giving you a ready-to-paint drawing.

**4. Projection.** Using an opaque projector is a real timesaver, because the machine projects the image from a photograph or sketch onto the stencil or shirt and lets you adjust the size of the image. Using vine charcoal (or white chalk if you are working on a black T-shirt), simply sketch the image. Projection is usually used for custom jobs for which the customer provides a photograph. The amount of time it would take to freehand an illustration is cut by at least half if you use an opaque projector.

**5. Drawing on the stencil or fabric.** Use this technique whenever possible because your drawing skills will improve and you will become more efficient. Vine charcoal is a good medium to draw with because of its softness, making it easy to use on fabric and easy to blow off or erase using your airbrush. (See the sidebar at left for information on erasing charcoal lines using your airbrush.) Your ultimate goal should be to draw with your airbrush on the painting surface, since this method will be the fastest

and most profitable.

## Basic Effects and Techniques You Need to Master

The following are the basic effects and techniques that go into the creation of most T-shirt illustrations. Practice and master all of these to enjoy broad creativity.

### Using Stencils

As a beginning T-shirt artist, you are smart to start out using stencils (sometimes called "masks") as you practice and master the basic strokes and techniques. Not only will stencils help you produce less frustrating, better looking results than you can presently spray freehand, but if you turn pro, you'll find that the combination of stencils and freehand spraying give you outstanding results *fast*. In fact, the T-shirt artists working the Florida tourist areas make their best money using a combination of stencils and freehand techniques. The stencils provide the sharp lines you can't achieve freehand, prevent overspray (generally, you can minimize overspray by holding your airbrush at a right angle to the T-shirt) and save you time. The freehand technique lets you add the gradation, texture, shading and detailing that take too much time to render using stencils. Freehanding is also used most of the time for lettering, again, because it's faster than using stencils.

Chapters two and three talk exclusively about stencils, so read this information thoroughly. You'll learn everything you need to know about stencil materials, how to design and cut stencils, and how to adhere them to fabric. Also, read each stencil step-by-step project. And pay attention to the stencil portfolio captions on pages 62-71; you'll find tips and secrets contributed by top artists.

## Freehand Spraying

Freehand spraying (see chapter four for more information and step-by-step demonstrations) means that you airbrush without using a stencil. Professional T-shirt artists use freehanding extensively as a speed technique, because it lets them produce and sell more shirts, especially custom shirts, for which stencils are not usually used.

Mastery of the freehand technique comes when you can control the airbrush trigger that supplies air and paint, when you know how close to the surface to position your brush, and when you can hold and move the airbrush with a steady hand. All of these skills come with practice.

You control the aesthetic quality of freehanding by the way you use the airbrush. By holding the needle close to the surface and pulling back on the trigger about one-quarter of its movable distance (this distance may vary for your airbrush) you can produce a fine spray or small points of color. When you hold the brush farther from the surface, lines and dots widen, and your freehanding becomes more sweeping to cover broader areas such as backgrounds or skies.

Since your freehand spraying can only be as good as your overall control of the airbrush, you should take every opportunity to practice spraying. Every professional T-shirt artist began just this way, by spraying hundreds of practice lines, curlicues and squiggles; moving the brush close to or away from the surface; and experimenting with air pressure and paint amount.

No one is born a master of the airbrush. Expect to render some less than pretty effects: Uneven line widths and irregular paint coverage are common. Practice and experimentation will eventually rid your illustration of these flaws.

Here are some basic tips for freehand spraying:

1. When outlining your sketch, use a smooth, fluid motion. Moving the airbrush too fast will result in an uneven application of paint; moving it too slowly will give you a ragged outline.

2. Create more interesting illustrations by varying the line thickness of your sketch outlines, using especially heavier lines in shadow areas.

3. When rendering script lettering, vary the line thickness; spray thinner lines on the upstroke and heavier lines on the downstroke.

## Highlights

Highlights serve many uses in T-shirt illustration. They create the illusion of dimension, give the sparkle to a metallic surface (see page 16), or produce the starburst effect popular in T-shirt illustration. (See page 16.)

To freehand highlights, identify where the highlights are located on an object by determining the direction from which the light is coming. Airbrush an *X* or a cross shape, tapering the lines away from the center. Add a spot of white paint in the center of the *X* or cross to increase the highlight's intensity.

To create highlights with stencils, predetermine where on the illustration you want the highlight to be, and then cut the highlight shape in a piece of stencil that will cover the illustration and expose only the highlight.

## Metallic Surfaces

Metallic surfaces feature distinctive characteristics that you can study in objects you see every day. A shiny car bumper, a brass necklace, reflective sunglasses, and many other common objects can teach you how light reacts

### The Three Keys to Making Exciting Art

**Key One:** Keep subjects simple. Study objects around you and simplify them mentally before you paint. Don't try to paint every detail. Less is usually more dramatic on a T-shirt.

**Key Two:** Learn through observation. For example, look at metallic surfaces, their colors, and what reflects off of them. Look at shadows. Shadows have color, and you must learn how to see these colors so your renderings will look realistic and attractive.

Look at work being done by artists in airbrush and other mediums. Greeting cards, posters, CD and book covers, and billboards are common applications of airbrush art. Look at advertisements and illustrations accompanying magazine articles. Learn how other artists handle certain subject matter, the colorations they use, and how they render various styles.

**Key Three:** Include lots of contrast in your artwork. Vary line thicknesses in the basic outline of the image; use areas of extreme dark (shadows) and light (highlights); and choose colors that contrast in hue and intensity.

## Getting Started Lettering

Before attempting to spray an actual name, you need to practice *a lot*. Begin by holding the airbrush about ½ inch from a practice surface, such as newsprint or kraft paper. Spray a straight line, varying its width from thick to thin by pulling back on the airbrush trigger; do not change the distance between the airbrush and the surface. Repeat this step, but now add looping lines of various sizes. Continue to vary the line widths. Practice spraying same-size loops to simulate same-size letterforms, elongated loops to simulate letters such as *y* and *j*, and actual letterforms, making sure their top and bottom edges are aligned and parallel. Draw horizontal pencil guidelines to help you gauge your accuracy.

Finally, practice these techniques on real names. Strive for variety, but consistency in thick and thin lines, parallelism of the tops and bottoms of the letters, and legibility. Once you have begun spraying an actual name, avoid stopping before you are finished. You do not want to have to go back over letters, as this is difficult to do well even after years of experience. And, even if you succeed fairly well, the lettering will look "reworked." Ideally, the only thing that should move as you spray is your forearm. Keeping your shoulder and waist still will ensure success.

While you are practicing, you should also practice placing and composing the lettering. Consider where the name will start and finish so it does not run around the side of the T-shirt. Also consider the composition of the name. For example, with script lettering the first letter of a name is usually capitalized and the remaining letters are lowercase; this composition looks attractive and polished. Feel free to dramatize the name by exaggerating letter shapes, which you see often in script lettering. For example, make the bottom bowl (loop) of a capital *E* much larger than the top bowl or make the dot on an *i* or *j* oversized.

to metal, where highlights fall, how strong the contrast is between darks and lights, and how reflected colors work.

The key characteristic of the shiniest metallic surface is the strong contrast between dark and light tones. As you diffuse this contrast (by softening the edges and bringing the tones closer together) the surface becomes dull, and your shiny-looking steel loses its sheen. If the contrast fades too much, the surface will simply look painted rather than reflective.

Another characteristic of metallic surfaces is gradated color that reflects the color of objects near the surface. A third quality, which is always the finishing touch that makes a surface shine, is bright highlights.

Classic metallic lettering is rendered with the traditional horizon line that represents reflectivity, which you can see on page 16.

### Texture

Texture is easily created with the airbrush: skin, hair, grass, sand, stars, feathers, wood, stone, marble, leather, and nearly any other surface you can imagine. Before you begin spraying a texture, study an actual sample of the object. See where there is shading and detailing, how strong the contrast is between colors, and how dominant the texture itself is. The following is a list of some spraying techniques used to create common textures.

**Stippling:** Sometimes called spattering, stippling is spraying tiny dots to create a grainy texture, such as stars, sand or granite. Usually you create a stippled texture by lowering your air pressure to 7 or 8 psi (pounds per square inch). You also can buy a spatter cap that attaches to your brush and creates the stippled effect as you spray. Textures created by stippling are often

used to represent stone, sand and the exterior walls of buildings.

**Sponging:** This creates an irregular, mottled texture. Dip a synthetic or natural sponge into your paint (full strength or diluted) and gently dab it onto the fabric. Make sure you protect any areas on which you don't want the sponged effect. With this technique, color and texture can be applied on top of airbrushed color. Textures often rendered by the sponge technique include that of cork, marble (try overprinting sponged colors on top of one another) and rusty metal.

**Stenciling:** Any of the common stenciling materials, such as polystyrene, Pellon, mylar or cardboard, can be cut into patterns or punctured to create texture. Spray through the stencil openings as you would normally. Experiment with unusual masking materials, such as window screening, lace, gauze and burlap.

**Coloration:** Although you don't normally think of color as having texture, it can produce textured effects. Colors are often stippled on top of one another. For example, you can create a stone effect by stippling yellow ochre, overlaying a gray stipple, and topping this with a white stipple for highlighting.

Color is also used to render wood. While it is especially helpful to have a wood sample at hand, the basic technique is to use lighter shades of color in the yellow-gray range, gradating them into one another, and adding darker, soft-edged bands of color to represent the grain.

Colored texture is achievable also by rendering a regular pattern of strokes of equal or varying lengths.

### Gradated Color

Gradated color is an effect that begins as a solid color and fades to white. T-

Texture in an illustration adds realism. You can render textures in your art using a variety of techniques and tools, including your airbrush, a paintbrush, a sponge or a toothbrush. The most common texture-producing techniques are described on page 8.

**Sand:** Stipple orange, black and brown to produce a grainy texture. Over the stippled texture spray light coats of yellow and brown. To add sparkle, stipple white as the final touch.

**Wood:** Render the grain of wood with brown, then spray light, overall coats of brown and yellow.

**Stone:** First, sponge light blue to create a base tone, over which you should sponge white to produce a coarse texture. A very light coat of black will dull the existing colors to resemble stone. Spray and shade the cracks with black.

**Metal:** Begin with light coats of black (or gray), then spray a light coat of blue for color. Add long streaks of gray and white to create the smooth, hard look of metal. Sponge brown and stipple orange to resemble rust.

**Fur:** Use brown to spray the hair texture, orange for overall color, black for the tiger stripes, and a few white hairs for highlight.

**Snakeskin:** Adhere plastic fishnet to the fabric with adhesive spray mount, then spray the color of your choice. Remove the net.

Gradation is a basic technique that you have to master, whether you airbrush with or without stencils, because the gradation technique makes it possible to produce realistic-looking shading and blending. Always lay down light coats of color to prevent bleeding and unwanted overspray when applying wide bands of color. Light coats of paint also let you build more intense colors.

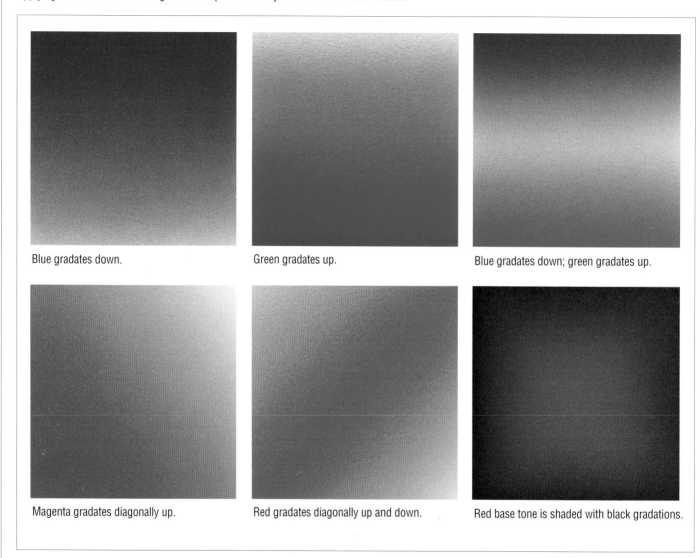

Blue gradates down.

Green gradates up.

Blue gradates down; green gradates up.

Magenta gradates diagonally up.

Red gradates diagonally up and down.

Red base tone is shaded with black gradations.

shirt artists use the gradation technique to render backgrounds, skies and sunsets; to give color and shape to objects; and to create a sense of distance, such as from foreground to horizon.

To gradate a color you'll need a steady trigger finger for consistent air pressure and paint flow, and a steady hand for consistent spraying and color coverage. While the uses of gradation are many, the technique used is the same, whether applied to a sweeping expanse of sunset sky or to a red-hot heart.

To spray a gradated area, hold the airbrush about 4 inches from the surface and start to spray from right to left and back again. Keep your stroke steady and rhythmic. Overlap and evenly space each stroke so your color coverage is consistent. Spray *toward* the area of the illustration that is to remain white. Repeat this process. As you progress along the gradated area, reduce the paint supply with each pass. As you near the last one-third of the area, lift the brush higher to reduce the spray coverage. Half of this final one-third should be colored only by overspray and the remainder left white.

## Lettering

Lettering is the dominant and most popular element airbrushed on any T-shirt. The most common lettering styles are script and bubble; other styles include metallic, neon and spike. Lettering is such a powerful design element that you can add it to a weak illustration and have something you can sell. The versatility of the airbrush lets you render most lettering styles.

As you explore lettering styles you must also become aware of specific techniques (such as freehanding, taper strokes, drop shadows and highlighting) that are necessary for creating lettering that is realistic, attractive and efficient to produce.

It is important that you plan lettering with the same attention you would an illustration. Do rough sketches, then modify and refine them to produce a tight, polished lettering drawing.

If you are lettering on a T-shirt, start practicing what many pros have learned from experience: Keep your lettering design simple. Since profitability in T-shirt illustration ultimately relies on quality, quantity and speed, you need to learn lettering styles that are easily rendered.

You can also purchase pre-cut lettering stencils or cut your own, until you can letter freehand. Avoid letters with serifs—short lines that stem from the strokes of a letter—as these are difficult to render consistently.

You can find visual references in typography books available in the library and in art supply and book stores. Photocopy pages, copy the letterforms, and combine them into whatever words or names you need. Use a photocopier to enlarge or reduce the letterforms to suit your project.

You can add texture, color, highlighting and three-dimensionality to lettering just as you can to an illustration.

## Adding Drop Shadows and Highlights

Drop shadows are easy to spray and add extra pizzazz to your lettering. To add a drop shadow, first render the lettering. Then move the brush about 1½ to 2 inches farther from the board (so the spray pattern is slightly wider and lighter) and repeat the lettering to the left and just below the original lettering. The resulting effect is that the

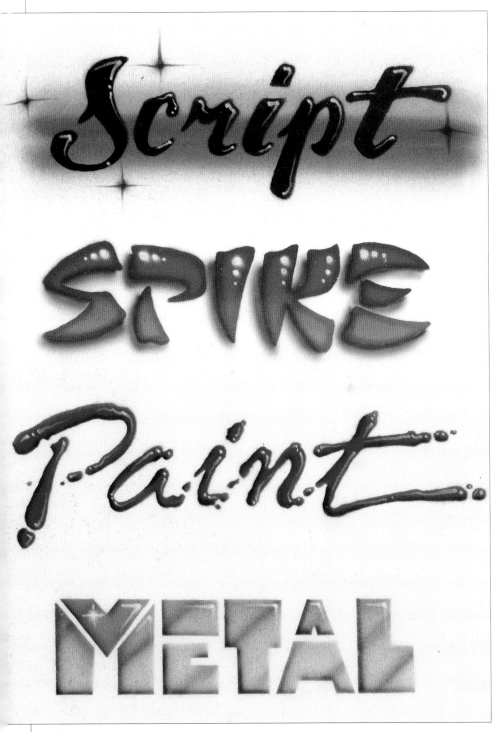

Stencil lettering is a good method for the beginning T-shirt artist to use, since it gives you more control over the end result. It does demand more time for planning and cutting the stencil, but the stencil can be reused. The styles available for stenciling are limited only by your imagination; the four below are some of the most common.

When designing your stencil lettering, be careful with the negative spaces, that is, the centers of letters (O, A, P, Q, etc.), which will fall out if you cut completely around them. Obviously, losing the negative space eliminates a critical feature that defines and identifies the letters. See pages 27-28 for more on lettering stencils that include negative spaces.

**Script:** You can render script lettering with a stencil or with freehand spraying. This style is used regularly for depicting people's names, especially in a romance-themed illustration. Black is the usual color for script lettering, since it lets you airbrush a name over most existing colors. Your own handwriting will affect the look of your script lettering. When planning your script stencil, do not connect the individual letters, otherwise, you will end up with a structurally weak stencil. See pages 36-37 for an example of a script stencil.

**Spike:** This is the stencil version of rattail lettering, which is shown on the opposite page. (Use black when adding spike lettering over other colors.) Spike lettering works best with all capital letters, and offers a somewhat Oriental look. The drop shadow adds depth and elevation. Construct the spike style using the basic taper stroke (see page 14).

**Paint:** This style can be rendered to look like any splattered liquid. Spray color more heavily around the edges, especially to the left side and the bottom, to create dimension. Highlights at the upper right enhance the dimensionality.

**Metal:** The key feature of metallic lettering is its reflectivity. Usually, blue represents the reflected sky and brown the reflected ground. If the lettering is part of an illustration, you also should include colors representative of elements surrounding the lettering.

## Freehand Lettering

Freehand lettering skills are needed by any professional T-shirt artist. Here are examples of some basic lettering styles, but you can invent many others. See the Professional Portfolio sections at the end of chapters three and four for other styles created by some of the country's top T-shirt artists. As you study other artists' work, note how they integrate drop shadows, highlights, starbursts, bands or spheres of color and other special effects. Apply these effects after the lettering is completed and before you add highlights.

**Script:** The basic characteristics of freehand script are the same as with stenciled script, shown on the opposite page. To render script freehand, however, you must be able to spray consistent line qualities and consistent letter sizes.

**Rattail:** This style, which works best with all capital letters, is less formal than script and offers a somewhat "wilder" image. Although shown here in red and blue, rattail is generally painted in black for the same reasons as script is. Construct the rattail style using the basic taper stroke (see page 14).

**Neon:** This is a very decorative style that imitates the look of neon lighting. It is usually rendered with bright colors, such as red, hot pink and lime green, which you cannot airbrush over other colors (as you can black) due to the transparency of fabric paints. Neon strokes are of consistent thickness; a soft overspray creates a glowing effect. You can apply the neon look to script or rattail styles.

**Toon:** This fun style is rendered most easily with black outlines, which are filled in with color. The style is most effective using all capital letters.

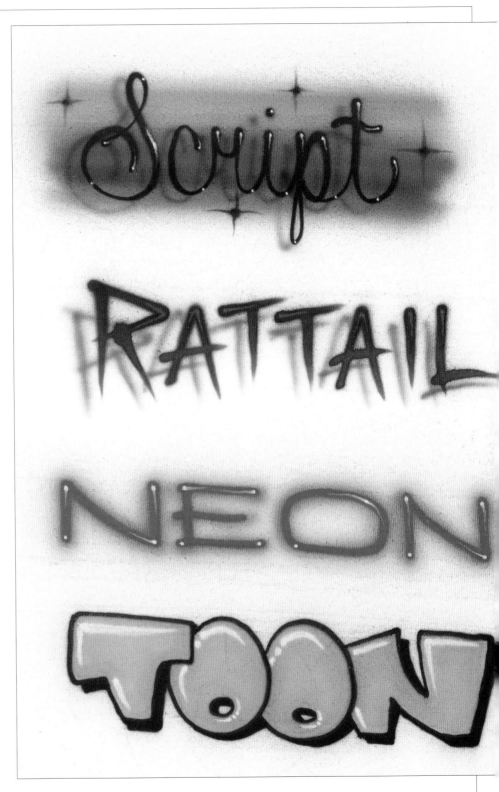

## Basic Strokes Exercises

By mastering three basic strokes (see below) you will have the skills you need to airbrush complete illustrations. The best, and only, way to do this is through serious and ongoing practice. No T-shirt artist was born with the ability to use an airbrush, so there is no shortcut to the process of gaining airbrush mastery. Successfully working the airbrush trigger in two directions at once (down for air and back for paint) requires finesse and a "touch," both of which you can acquire in fairly short order, if you practice.

*(left)*

**The Dot:** To spray a dot, point the airbrush directly at the spot where you want to apply the painted dot. Press the trigger down to start the air flowing, then pull it back to release the paint. Hold the brush steady as the paint flows. The distance of the brush from the surface and the distance the trigger is pulled back determine the size of the dot.

*(center)*

**The Line:** You airbrush lines in essentially the same way as you do dots except that you move the airbrush directionally as you spray. Line thickness is determined by the distance of the brush from the surface and the distance the trigger is pulled back. Keep these elements consistent to maintain a uniform line thickness.

*(right)*

**The Taper Stroke:** The taper stroke, also called the feather or flare stroke, is a basic airbrush line that literally tapers off to a fine point. Taper strokes are often used to render palm tree fronds or sea oats, starbursts, textures and linear highlights.

To airbrush a taper stroke, begin spraying a normal line. (The closer the brush is to the surface, the thinner the line.) Just before you want the line to stop, gently push the airbrush toward the surface so it is nearly touching it. At this point, allow the trigger to move forward so the paint flow stops, but keep the trigger pressed down so the air flow continues.

Mastering the taper stroke requires coordination. The natural tendency for beginners is to move the airbrush away from rather than toward the surface or to snag the fabric with the needle. These problems will disappear with practice. Make sure that you do not stop the air flow too soon or you will end up with a dot at the end of your stroke.

**Dot Exercise:** This exercise develops basic airbrush control. Begin by spraying a small center dot, holding the brush so it nearly touches the surface. The trigger should be pulled back only slightly. To compose the surrounding dot pattern and to spray larger dots, hold the brush in the same place, and begin spraying. As soon as you see a dot of paint, pull the brush back and keep spraying until the dot is the size you want. Repeat this process for each larger set of dots. Remember, since your paint coverage will lighten as you move the brush farther from the surface, to maintain the same color intensity you have to increase the amount of paint being sprayed by pulling back on the trigger, too.

**Special Effects Dot Exercise:** This exercise demonstrates how to add dimension and depth to a simple shape. First, make two rows of different-sized dots.

To the top row add drop shadows and small white highlight dots. On the bottom row, spray a soft tone (of the same color as the original dot) around each dot, by doubling the distance between the brush and the surface.

**Lines and Tapers Exercise:** The first half of this exercise will help you learn how to maintain uniform paint application. Spray a column of lines of different thicknesses. For the second half, which will help you learn to change line thickness without stopping the airbrush, spray a column of taper stroke lines, with alternating lines tapering in opposite directions.

**Special Effects Line Exercise:** This exercise teaches the ability to turn simple lines into special design elements or effects. First, spray a straight line, holding the brush any distance from the surface. Double the distance between the brush and the surface, and add a drop shadow. Finish with a tapered highlight. Next, spray a squiggle line, again holding the brush any distance from the surface. Now, move the brush twice this distance, hold the trigger in the same position, and add a soft application of paint around the squiggle (for a glowing effect). Finish with tapered highlights.

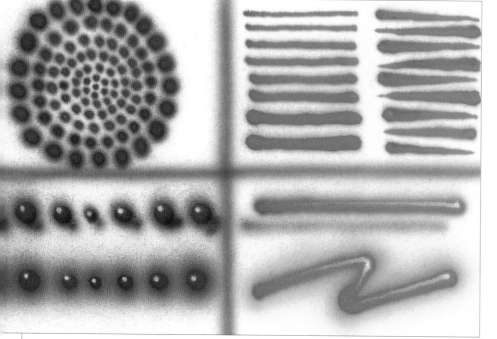

original lettering seems to float above the painting surface. White highlights, like cake icing, take the lettering that last step by adding crispness and polish and by defining the shape of each letter. To create highlights, simply follow the contour of a letter with a thin line.

## Airbrushing on Fabrics

The surface quality and the color of the fabric you choose will affect your illustration. If you are airbrushing white T-shirts, you need not worry about fabric surface and color. Neither factor will interfere with the airbrushing techniques or fabric paints you use. But if you decide to airbrush a red sweatshirt or a leather jacket, you need to consider how the color and the fabric will react with the paint and the techniques you use.

### Fabric and Line Quality

If you have airbrushed on illustration board, you know about the different line qualities you can create, including ultra-hard-edged if you use acetate or frisket masking, and soft and diffused if you spray without masking. Spraying on fabric is a very different experience from working on illustration board.

The absorbency of fabric causes the paint to spread into the fibers, softening the sprayed line. Spraying on fabric with stencils will never give you the hard edge you can get on illustration board, but it is the way to create the crispest possible line on fabric.

### T-Shirts and Sweats

The best T-shirt and sweats fabric for airbrushing is 100 percent cotton, because it absorbs paint well, but not too much, and it offers a fine, silky surface. However, T-shirts made of a cotton-polyester blend are a suitable

### Special Effects Chart

Whether freehand spraying or using stencils, you can create special effects to give dimension, sparkle and detail to any illustration or to cover up mistakes, which even professionals make.

**Highlights:** Highlights are discussed on pages 7 and 11-15. The typical highlight shapes are a dot and a tapered line, which are used in different situations. The most comprehensive way to discover how these strokes are used as highlights is to take about ten minutes and leaf through this book, looking only for the highlights. You will see that dot highlights are often used on script lettering or on small circular shapes such as water drops or air bubbles. Tapered highlights are used more often on larger shapes such as block lettering, three-dimensional objects or metallic surfaces.

**Drop Shadows:** This effect, when sprayed lightly beneath a shape, adds dimension to an object and depth to an illustration. You will see drop shadows beneath lettering and three-dimensional objects; the resulting effect is one of elevation. See pages 11-15 for more information.

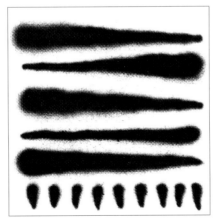

**Taper Stroke:** The taper stroke technique is described in detail on page 14. You would use this stroke for a variety of purposes, including as a highlight, starburst, texture or contour line, or in lettering.

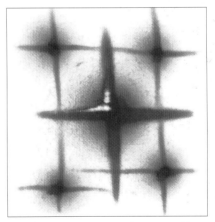

**Starburst:** You can use starbursts to add shine and sparkle, or simply decoration, to nearly any illustration. You can create starbursts with a stencil or freehand. See page 16 for more information.

## Airbrushing Starbursts and Metallic Effects

You will see starbursts used often in T-shirt illustration, as a way to enhance the imagery and give it more radiance and pizzazz. Here are examples of freehanded and stenciled starburst effects.

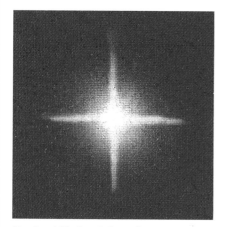

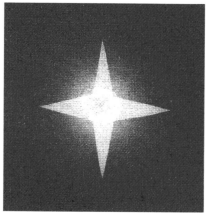

**Freehand Starburst:** Spray four taper strokes radiating out from a common center. At the center point, add a light circular area of tone to create a glowing effect. To larger starbursts, add highlights for extra sparkle.

**Stenciled Starburst:** Draw a starburst directly on your stencil material, and cut it out with an X-Acto knife with a no. 11 or 16 blade. Spray a light coat of adhesive on the back of the stencil, and position it on your illustration where you want the starburst to appear. Spray at least three light applications of white paint, concentrating the spray at the center of the starburst and gradating the color toward the end of each tapered shape.

**Chrome:** The goal in airbrushing any shiny metallic surface is to make it appear reflective of surrounding colors. The example of chrome, left, shows the standard rendering method: Blue is sprayed on the top half to represent the reflected sky and brown is sprayed on the lower half to represent the reflected ground. Notice the thin, dark brown line across the center, which indicates the horizon. The blue gradates toward this horizon line, and the brown gradates away from it. Black defines the object's overall shape and adds important contrast, which is another characteristic of a metallic surface. White starbursts and tapered highlights enhance the shininess; the drop shadow lifts the shape from the page. (Notice the crispness of the black outline; this quality was produced with the use of a stencil. Freehanding would result in a much softer edge quality.)

painting surface, and they tend to be less expensive and easier to care for.

The thin, smooth surface of a T-shirt lets you render clean, thin lines and as much detail as is possible on fabric. Thicker fabric, such as fleece-lined sweatshirts or pants, creates softer, more diffused lines and lessens the amount of detail you can achieve. Do not wash either fabric before you airbrush, because washing roughens the surface, which will result in even softer lines and less detail. If you want to spray on an old T-shirt, bleach it first in a normal washing machine cycle, then iron it. Do not use straight bleach on even an old T-shirt, and do not use *any* bleach on a new shirt.

### Canvas

You can airbrush on canvas that is primed or unprimed. Unprimed canvas has a woven, somewhat textured surface that absorbs paint and creates the soft line quality you see on T-shirt fabric. Primed canvas, which has been coated with a medium called gesso, has a smooth, less porous surface that prevents much paint absorption. A primed canvas surface reacts to paint much like a leather surface does: Paint tends to sit on the surface, and if you hold the airbrush too close to the surface you risk splattering the paint.

Unprimed canvas is available in your local art supply or fabric store. If you plan to prime your own canvas, you should stretch it over a frame before applying the gesso; you can also prime the fabric with vinyl interior wall paint, which is less expensive than gesso. To save time, apply the medium with a roller rather than a brush. Lightly sand the gesso or house paint once it is dry. The frame and the gesso are available at art supply stores, as is primed, pre-stretched canvas.

## Leather

Leather's smooth finish keeps paint from being absorbed into its fibers, which means that the paint sits on the surface. For this reason, you must be careful to avoid splattering the surface as you airbrush. To prevent splattering, hold the airbrush at least 1/4-inch from the surface and do not pull the trigger back more than one-quarter of its moving distance. (As always, a number of factors—your brand of airbrush, paint consistency and the leather's softness—may require variation in these distances.)

Before you begin, rub the painting area of the leather with rubbing alcohol to remove any oil; leaving oil on the fabric will cause your paint to separate from the surface. The process of airbrushing on leather then becomes like that of working on any black fabric. For step-by-step instruction see the demonstration on pages 91-95.

Detailing is difficult to add to an illustration on leather due to the tendency of the paint to splatter. Here are some tips for adding detail to leather:

1. Use black or white paint, which is generally thicker and less likely to splatter;
2. Avoid trying to render tiny details that most people will not even notice;
3. Practice spraying small dots and lines on primed canvas or on posterboard. If you can keep paint from splattering on these surfaces, you can do the same on leather.

To preserve an illustration on leather, first heat-set the illustration (see the sidebar on this page), then apply a coat of clear enamel spray. Do not use lacquer; it will destroy the illustration.

Before you tackle your first piece of leather, become proficient by airbrushing on T-shirts and primed canvas. To produce a leather-like surface on canvas, paint the canvas black before you begin an illustration.

## Denim

Denim is essentially the same surface as unprimed canvas. To prepare blue or black denim for painting, apply multiple undercoats of white paint, as you should for a dark T-shirt. (See page 18.) Then spray your colors on the white undercoat. Some artists first spray the painting area of the denim with a 50-50 water-bleach solution, which they leave on until they achieve the desired fade. If you try this technique, be sure to rinse the solution out thoroughly, and run the garment through the dryer until it is completely dry. Be careful to bleach only the area you will paint.

Stonewashed denim is an interesting alternative to regular denim. The irregular stonewashed coloration shows through the paint layers and adds unusual texture and shading to your illustration.

## Nylon and Spandex

Jackets and pants made of 100 percent nylon or lycra do not take paint well. You should spray on fabric that has at least a 50 percent cotton content to ensure some paint absorption. An exception to that is Spandex, which, for unknown reasons, takes paint well. When working on a stretchy fabric like Spandex, remember that your illustration will probably be distorted when the garment is being worn. If possible, stretch the fabric as you airbrush in the same way it will be stretched when worn. For example, if you are spraying a Spandex bodysuit or leotard and your customer is adventurous, ask her to wear the suit while you airbrush on it. Although the paint will go through the Spandex onto your customer's skin, the paint is water-based and will wash right off.

### Heat-Setting Your Art

The paint that you spray onto a T-shirt, or other fabric, should be "set" or made permanent so your illustration does not suffer during washing and wearing. To set an illustration, you must expose it to a high temperature, ideally of around 350 degrees.

The method used most by professional artists is the heat press, which presses a shirt for 25 to 30 seconds under temperatures around 350 to 375 degrees. The average price for a good heat press is around $600. Check with a local T-shirt shop about using their heat press; some will allow it as a courtesy or charge a nominal fee.

The two top-of-the-line methods for heat-setting, which are not cost effective for most independent T-shirt artists, are the commercial conveyer dryer (priced from $3,500 to $15,000) and the flash cure unit (priced from $500 to $800). You can contact a silkscreening shop about using one of these machines.

If you have no access to the above methods, you can, as a last resort, use an iron or clothes dryer before the item is washed. Set the iron to its highest heat and hold it on the illustration for 20 to 30 seconds, or put the dryer on its hottest setting and let it run for about 45 minutes. The results will be less permanent with these methods—the paint will tend to wash out more over time—but they are definitely better than doing nothing.

## Dark-Colored Fabrics

Fabric color is an important consideration when airbrushing. Dark colors—black, red, royal blue, navy, kelly or forest green—whether on T-shirts, denim or leather, will affect your paint color because the transparency of the paint lets the fabric color show through.

The key to successfully airbrushing on dark fabric is to spray at least three light coats of white paint as the foundation of your illustration. Let the coats dry between applications. If your white paint does not produce very opaque applications, you may need to spray more than three coats. You want a thorough application because whiter surfaces give better results. If you should overspray beyond your illustration area on a black T-shirt or leather, simply cover the overspray with black paint.

The next step, before beginning your illustration, is to heat-set the white base so it becomes permanent. Use one of the heat-setting techniques described on page 17. Once the base is set, airbrush as you would on a white T-shirt. You may need to repeat applications of paint, if the applied paint color is not as vivid as you want.

Except for denim (see page 17), do not use diluted or straight bleach to lighten fabric before airbrushing. Bleach will weaken the fabric and could cause holes if left on too long. Be sure to rinse and dry the garment before painting.

To sketch on dark fabric, use white chalk, which you can blow out with your airbrush (see page 73) or wash out.

## Textured Fabric

Textured fabrics, such as rough grades of canvas, corduroy or deep suede, pose a problem if you want to use stencils. A stencil will stick well to a T-shirt surface, but on a textured surface it sticks only to the surface nap. This leaves a gap under the stencil allowing room for unwanted underspray. To avoid this, always spray while holding your airbrush at a right angle to the stencil edge. Seams on denim jackets or pants also keep stencils from lying flat on the surface, so hold your airbrush at a right angle to any fabric seam.

## Other Objects

Popular objects for airbrushing include visors, caps, cloth belts, tennis shoes, tote bags, socks, sheet sets, curtains and place mats.

Regardless of what you are spraying, it must be secured to some type of stable board—corkboard, cardboard, plywood or shirtboard work well. Large items, such as oversized tote bags, can be wrapped around the board, and loose fabric pinned behind the board out of the spraying area. Smaller objects, such as visors, ballcaps and belts, should also be pinned to the board so they do not shift as you spray. Wig heads are effective for holding visors and caps during spraying.

For very thin fabrics (such as sheets or curtains) that are too large to wrap around a board, place a piece of paper or cardboard behind the fabric to protect your wall or other vulnerable areas from the paint that will go through this fabric.

## The Essential Tools

The tools described below constitute everything you need to get started airbrushing on T-shirts.

### The Airbrush

There are three kinds of airbrushes on the market: double-action, single-

action and turbo. The double-action offers you the best spraying options at a reasonable price, letting you create a great range of effects and textures just by controlling the air flow, the amount of paint sprayed, and how close you hold the brush to the surface. The double-action airbrush lets you spray lines that are broad or thin, cover large areas, gradate color and do fine detailing.

While the single-action is the most affordable, its use is very limited and this might quickly frustrate you. The turbo is the most expensive and works best for detail work.

Professional T-shirt artists who need to produce finished T-shirts very quickly may have two to three dozen double-action airbrushes at hand so they don't have to keep cleaning brushes in order to change paint colors. The cost of this set up eliminates it for most beginners. Don't be discouraged, because you *can* work successfully with one airbrush. You will, however, have to change color jars often and flush the brush out with each jar change. As your skills, and your finances, improve, you can purchase additional airbrushes.

**How to choose an airbrush.** There are many different, and suitable, airbrush brands available. Here are tips for choosing the right brush for you.
1. Hold a brush before buying it. It shouldn't feel too heavy and your fingers shouldn't feel cramped.
2. Ask your dealer if you can borrow a demo model so you can really test it.
3. Do not buy the top of the line brush. You will need a bottom feed, double-action brush with a medium head assembly. These brushes are less expensive than those used by commercial illustrators, in addition to being more versatile and rugged. The double-action feature lets you control the amount of air and

paint, and the bottom feed lets you attach jars of paint onto a siphon tube and change colors quickly.

**How to operate an airbrush.** Grip an airbrush as you would hold a pen or pencil. Your thumb goes on the side and your forefinger on the trigger. The forefinger works the trigger up and down to control air flow, and forward and backward to control paint flow.

To produce good quality, steady lines and tones, follow this golden rule of airbrushing: Air on first, off last. Begin your spraying motion ahead of your actual target area by depressing the trigger for air only. As the nozzle reaches the target area, draw the trigger back for paint. When you reach the target end point, shut off the paint flow but keep the air flowing just beyond the edge of your target area.

**Air Sources**

T-shirt artists rely on a wide range of air sources. Base your choice of air source on your budget and your working environment.

Remember that an air source must be compatible with your airbrush so that it delivers clean, dry air. Airbrush manufacturers recommend certain pressures for their brushes that, if used all the time, will likely give you some unsatisfactory results. Most professional T-shirt artists use pressures ranging from 40 to 60 psi. Others spray using pressures over 70 psi; this produces results faster, but it also produces more overspray. Begin with 40 psi, but experiment with varying air pressures to learn how to render the range of airbrush effects described throughout this book.

Check a local airbrush supply house for additional manufacturer information on air sources. The

The double-action airbrush is reasonably priced and versatile, allowing you to create a great range of effects and textures.

## Using a Piston-Driven Air Compressor

The piston-driven air compressor is the best air source for the T-shirt artist who requires high and consistent air pressure to maintain productivity and to power, usually, more than one airbrush. When shopping for an air compressor, it's best to purchase one with a minimum of 1 horsepower and a 7-gallon air tank, in addition to a pressure regulator.

A compressor that comes with an air tank does not run continually, which minimizes noise. When the pressure in the air tank drops to a pre-set point, the compressor turns on automatically, shutting off when it reaches a pre-set maximum. (The noise of the compressor turning itself on can be startling.) Also, the larger the motor (horsepower) and the larger the tank (gallons), the less the compressor will run.

To maintain your compressor:
1. Drain condensation from the tank daily.
2. Maintain the proper oil levels if your machine requires this.
3. Change the air inlet filter periodically.
4. Follow the manufacturer's maintenance instructions.

detailed descriptions, below, of various air sources will help in making a selection.

**CO² tanks:** A CO² tank is the best choice for the beginning T-shirt artist who is on a limited budget. It is quiet, clean, and the air is dry. One 15-pound tank will give you about twenty to thirty hours of air. A T-shirt artist working eight hours a day may refill every two to three days. Along with a tank you'll need a moisture separator and a pressure regulator made specifically for CO² tanks. The regulator needs two gauges, one showing gas and the other showing the pressure you are using. You'll need about 30 to 50 psi. Before purchasing a tank, consider testing this air source by renting one from a local welding or beverage supply company.

**Silent compressor:** This expensive compressor is not the ideal air source for the T-shirt artist. Generally, it cannot withstand the constant high pressures and frequent use that T-shirt airbrushing requires. Typically, the silent compressor will burn out under this kind of use.

**Spare tires:** Although spare tires are inexpensive and readily available, they have some serious drawbacks: Air pressure drops constantly, and the air can be damp and dirty. If you choose this air source, the tire must include the inner tube and rim. You'll also need a special adapter that fits the tire's valve and connects to an air hose.

**Compressed air can:** Consider this air source only for short-term use because over the long term it becomes very expensive. The cans are filled with an inert gas, so they sometimes freeze as you use them. (One artist, who casually rested a can against his face, had it freeze to his beard!) Freezing will reduce or cut off your air supply and your painting time, not to

mention your beard (if you have one).

**Diaphragm compressor without air tank:** This noisy compressor is small (1/8 to 1/2 horsepower) and is commonly sold at art supply stores. Because it lacks an air tank, it's difficult to maintain a consistent air pressure when airbrushing.

**Diaphragm compressor with air tank:** This 1 horsepower compressor, although noisy, does a pretty good job of supplying air for the T-shirt artist. Its air tank, which must be fitted with a pressure regulator, provides a consistent air supply. It can be purchased at a hardware store, and is the least expensive of the tank-equipped compressors.

**Piston-driven compressor with air tank:** This is the best choice for the T-shirt artist. Most piston-driven compressors are at least 1 horsepower and have a 7- to 12-gallon air tank, which is ideal (although you can work with less). Its built-in pressure regulator delivers consistent and abundant air pressure, enough to power multiple airbrushes. Check your local hardware store.

## Acrylic Fabric Paint

As a beginning T-shirt artist, you should use acrylic fabric paint that is formulated for the airbrush and is ready to use. Although you can mix your own fabric paint, producing the right consistency is very difficult and is not advised until you gain experience. Popular pre-mixed brands include Badger Air Tex, Perm Air by Deka and Aqua Flow. Whichever brand you choose, it should offer a range of colors and have consistent shades. Once applied to a garment, paint must be colorfast, washable and resistant to cracking.

As you work, keep in mind that because acrylic paint dries quickly, it

may clog your brush. You can remedy or even prevent this by wiping the airbrush needle often. (See pages 21-22 for other cleaning and unclogging techniques.) Once dry and heat-set, acrylic fabric paint will not wash out of a T-shirt; however, the color will fade if you do not use a heat press, commercial conveyor dryer or cure unit (see page 17).

A standard color palette for beginners includes red, blue, purple, yellow, black, white and brown. White is a particularly useful color because you can use it to cover painting mistakes. With practice you can create new colors by overspraying yellow and blue to make green, red and yellow to make orange, etc.

Don't buy more than a six-month supply of paint; the older the paint, the more likely it is to clog your brush. Store the paint in color jars (available at art supply stores) that snap onto the siphon tube of your airbrush. Make certain the jars fit your particular brush or brushes and are interchangeable if you use more than one brush. Periodically pour the paints from the jars through a strainer to keep them fluid and to prevent clogging. (See page 22 for information about strainers.) Don't let the paint get hot, since this causes it to thin out and expand, and potentially to run up and out of the jar opening.

## Other Equipment You'll Need

**Respirator mask:** Even though acrylic fabric paint is non-toxic, hazardous overspray can build up in your lungs if you don't consistently wear a respirator mask. You should also work in a well-ventilated area.

**Shirtboard:** A shirtboard can be any type of rigid board—corkboard, cardboard or Masonite—that you slip inside a T-shirt to hold and flatten the

fabric for spraying. The board should be roughly 18" x 22" for most work, although it is useful to have a few different sizes since you may spray garments for infants as well as for professional football players.

Corkboard works especially well because it is absorbent and inexpensive, and small objects, such as tote bags and visors, can be pinned to it for painting. Cardboard is usually the most available and inexpensive material. Masonite is the most durable. As a beginner, use whichever material you have at hand, but do not use plywood, which will snag your T-shirt.

To use the shirtboard, slip the T-shirt over the board, wrap the loose fabric to the back of the board, and pin or tape it down so the front of the shirt is taut. To help hold the shirt in place, apply spray adhesive lightly to the board before you position the shirt. Press the shirt against the board to secure it to the adhesive. The adhesive will wash out of the shirt; it will also remain on the board so you do not have to apply new adhesive with each shirt.

You can also stuff a garment area such as a sleeve or leghole with newspaper to fill it out before spraying.

**Drawing mediums:** Use vine charcoal for light colored garments, chalk for dark colored garments, and transfer paper for drawing on stencils.

**Miscellaneous:** You'll also need a whisk small enough to fit inside a paint jar for stirring; a roll of paper towels or some clean rags; a small brush for cleaning your airbrush; a straightened paper clip and a spray bottle for clearing brush clogs; a water jug for cleaning or spritzing your airbrush; window cleaner for the cleaning brush; acetone (which is the same thing as fingernail polish remover) for cleaning dried paint; adhesive spray

mount; extra paint jars with siphon lids in case one breaks or clogs so it can't be cleared quickly; a 60-mesh strainer; and Teflon tape or plumber's tape to apply to the threads of your airbrush air valve and all air connections to prevent air leaks.

## Primary Tools You'll Need to Go Pro

Here are the tools you will need to make a living making T-shirt art.

**Four or more airbrushes:** Purchase one each for black and white; at least one for a warm color (yellow, red, orange or brown) and one for a cool color (blue, green or purple). If needed you can easily clean the warm or cool color brush to introduce a new color. Do not use cool colors in your "warm" brush or vice versa as this will muddy the colors and slow down your color changes.

**Painting easel:** Set up an easel, or something similar, to hold your shirtboard nearly vertical while you work. You can buy or build one at a fairly low cost.

**Large piston compressor:** You'll need at least a 1 horsepower compressor with a 7- to 12-gallon air tank, a regulator, and a moisture trap.

**Manifold:** This is used to hook up multiple airbrushes to a single air source. You can buy one or build one from ¼-inch pipe fittings available at hardware stores. Apply Teflon tape to the pipe threads of all joints before assembling to prevent air leaks. Bolt the manifold at the base of an easel. See the illustration at right.

### How to Construct a Manifold

When you decide to go pro as a T-shirt artist, you will probably need more than one airbrush. You'll save yourself time by buying or building a manifold that will let you attach mul-

tiple airbrushes to a single air source. Here's the recipe for constructing a four-outlet (four airbrush) manifold.

Buy ¼-inch galvanized pipes: two elbows, three tees, five 2" x ¼" nipples, four 1" x ¼" nipples, and a roll of Teflon tape. Wrap all the pipe threads with Teflon tape to prevent air leaks. Screw the three tees together in a row using the 2-inch nipples and attach an elbow at each end. Point the tees and the elbows in the same direction and screw a 2-inch nipple into one of the elbows. (Your pressure regulator and moisture trap will attach here.) Screw the four 1-inch nipples into the tees and the second elbow. (Your airbrush hoses will attach to these openings.) Finally, attach the manifold at the base of a sturdy easel using U-bolts.

## Preventing or Cleaning a Clogged Airbrush

The best way to prevent clogging is to strain your paints regularly. Paint tends to settle and coagulate, forming clumps or strands that prevent the paint from atomizing properly, and spitting may result. Keeping your paint strained also prevents paint buildup on the airbrush needle and

Professional T-shirt artists save time and money by using a manifold, which lets them attach multiple airbrushes to a single air source. You can either buy a manifold or easily construct one from ¼-inch pipe fittings (see instructions above).

The best way to prevent a clogged airbrush is to strain your paints regularly.

tip. Check your local art supply stores for plastic strainers with stainless steel mesh inserts; the best mesh size for straining ready-made airbrush paint is 60. Or for an economical alternative, purchase a standard kitchen strainer. You can also use organdy (check fabric outlets) or the inexpensive, disposable paper strainers sold at automotive stores.

Thoroughly cleaning your brush and spritzing it as you work are other must-dos. The water jug is handy for cleaning or spritzing. To spritz your brush, submerge it beyond its siphon tube into your water jug, but not so far that the brass fittings in the back are submerged. Spray air to circulate water throughout the brush. If spritzing doesn't solve a clog problem, you need to disassemble and clean the brush, following the manufacturer's guidelines.

White, brown and fluorescent paints clog most frequently, while black tends to build up on the tip. Each time your brush clogs make a mental note of where the clog is. This will make future unclogging faster

since you will become more familiar with the eccentricities of your airbrush and paints. Try these tricks when your brush clogs:

1. Wipe the needle.
2. Increase air pressure 3 to 4 psi.
3. Pull the nozzle off and spray into the water jug.
4. Use a spray bottle to apply water directly into the brush.
5. Attach a paint jar with water in it and spray the water through the brush.
6. Run acetone through the brush if paint has dried inside. Always wear a mask when you use acetone to keep from inhaling the fumes.
7. Use a straightened paper clip to clear a clog in the siphon tube.

**How to Troubleshoot Problems**
Here are some common problems that T-shirt artists encounter, their probable causes, and the solutions that usually work. For solutions requiring disassembling your airbrush, first read the instruction manual that came with your brush.

Problem: Faulty air flow from compressor.
Solution: Check the supply of electricity and the connections between the hose and the valve.

Problem: Paint fails to spray when trigger is engaged.
Solution: Strain the paint; it may be too thick. If that doesn't work, remove the needle and the nozzle and clear any dried-on paint. Also, check to make sure the needle locking nut isn't loose. Or it may be that the trigger is broken, in which case you should return the airbrush to the seller.

Problem: Paint spits or spatters on the surface.
Solution: Too much paint may be coming out; do not stop moving the

brush while pushing the trigger down for paint. Also check that your air pressure isn't too low. Thick paint can cause spitting and spattering, so strain your paint. Check that the needle is straight (a bent needle could cause paint build-up in the nozzle cap). Or it may be time to replace a worn or damaged nozzle.

Problem: Spray pattern is irregular.
Solution: Strain paint to clean out impurities or remove and clean the needle and nozzle.

Problem: Paint creates spider webs on fabric.
Solution: Move airbrush farther from surface, adjust the needle (it may be releasing too much paint), or simply practice spraying more.

Problem: Can't produce a fine line.
Solution: Strain paint to thin it, raise your air pressure, or check to see if the needle or nozzle is damaged (and replace, if so).

Problem: Paint bubbles or seeps from the color jar in spurts.
Solution: Tighten the head assembly. If the problem continues, clean the head assembly.

Problem: Paint oozes from the color jar.
Solution: Either the paint has gotten hot or the vent hole in the paint jar's lid is clogged. First, try clearing the vent hole using a straightened paper clip. If the cause is hot paint, allow it to cool before straining it. Keep the paint out of direct sunlight or excessive heat in the future.

Problem: Water comes out of your airbrush.

Solution: Flush out the bulb of your water trap and drain excess water out of the air line.

Problem: You press the trigger down for air only, and paint comes out.
Solution: Unscrew the handle and loosen the locknut. While pushing the needle up, tighten the locknut.

Problem: A double or fuzzy paint line results from spraying.
Solution: Remove the regulator cap from the airbrush head assembly, and gently clean the needle tip and the regulator cap.

Problem: The airbrush is clogged, keeping paint from coming out.
Solution: To remove paint particles clogging the tip, pull back on the trigger and cover the airbrush tip with your finger for *one* second. Remove your finger from the tip, keeping the trigger pulled back; the clogging particles should come out. If not, see page 22 for other ways to unclog an airbrush.

Problem: Paint shoots out the top of the color jar when you remove it from the airbrush.
Solution: Clear the vent hole in the color jar lid using a straightened paper clip before you begin airbrushing.

## Making Money From T-Shirt Art

To become a successful T-shirt artist requires strong, efficient skills in all of the airbrushing techniques shown in this book. You must invest hundreds of hours in practicing the techniques and in spraying on fabric, especially on T-shirts. Many artists begin their careers by airbrushing T-shirts for their friends and family, which is a good way to ease into the business. At some point, though, you must move beyond your immediate circle of friends/customers in order to make more money.

T-shirt airbrushing is generally seasonal work: Summers and Christmas are the busy seasons. The heaviest tourist traffic is in Florida; the major league T-shirt artists work places such as Panama City Beach and Fort Walton Beach, where they can earn hundreds of dollars a day. The six-month Florida season (March to Labor Day) requires that artists work long days (up to eighteen hours) and seven-day work weeks. Balancing volume with quality is the key to success, and the best artists spend only seven to fifteen minutes on a shirt.

Ultimately, it will be your choice where you work and for how long. If you prefer not to travel, check in your local shopping mall for a T-shirt shop, where hours will be less strenuous and the income potential still good. Other local opportunities include fairs and festivals, flea markets and amusement parks.

## The Six Major Airbrush Markets

Airbrush artists involved in non-commercial illustration work primarily in six markets: T-shirts, clothing and accessories; canvas painting and portraiture; sign painting; glass etching; fingernail painting; and cake decorating.

The most popular and profitable market, and the one that this book focuses on, is airbrushing on fabric. This is a large and accessible market for the beginning or advanced artist. To get started, you can purchase the basic equipment for less than $400. (See pages 18-21 for a list of basic equipment.)

The T-shirt market includes many types of paintable clothing and objects besides T-shirts: sweatshirts, hats, visors, T-shirt dresses, jeans, jean jackets, leather jackets, tank tops, half-length athletic shirts, baseball shirts, tennis shoes, tote bags, key chains, bodysuits and socks.

### Buying an Inventory of Blank T-Shirts

Blank—unprinted—T-shirts (or other items) can be purchased in any department store at retail prices, but they are thinner and flimsier than the shirts you buy from a T-shirt supply company. If you acquire a business sales tax identification number, you can order shirts by mail wholesale. Wholesalers will request your tax number and in exchange you receive a discount. Check the yellow pages for local wholesalers. For national wholesalers and additional business information, see *How to Make Money With Your Airbrush*, by Joseph Sanchez (North Light Books). Wholesalers who ship products to you will expect cash payment upon delivery.

Shirts are available in three blends: a mixture of 50 percent cotton and 50 percent polyester, 100 percent cotton heavy-weight, or 100 percent cotton

Routine maintenance of your airbrush includes using a water jug to spritz your brush as you work.

## Where to Work

Many artists prefer to work in a public setting with immediate customer traffic. You have two basic options: You can join the staff of a T-shirt shop or you can rent space somewhere but still be your own boss.

Becoming a staff artist is a simple, fairly stress-free way to make art without enduring the business hassles. You'll also gain experience before venturing out on your own. Identify shops that currently have staff airbrush artists and/or shops that you think could benefit from having a staff artist. Contact the shop owners and ask for an appointment. Always, always, *always*, when you meet with any shop owner, have a sales strategy. Dress nicely, act businesslike, take a dozen of your best samples (actual shirts and/or good quality photographs of your work), and go armed with persuasive reasons why you should be hired.

Renting space to work (usually a stand or booth) where there is good customer traffic has many advantages. For a monthly rental fee, you avoid the responsibility of maintaining a location and in return you get lots of exposure. Look for rental space at shopping malls, festivals and fairs, flea markets and local tourist spots, such as amusement parks, waterparks and beaches. Some phone work will uncover the person with whom you can discuss and negotiate an arrangement. Once this is done, it is your responsibility to show up, set up and get customers.

regular weight. The 50-50 blend is more affordable and won't shrink. If you purchase 100 percent cotton shirts, look for pre-shrunk shirts.

### Popular Subject Matter

Your airbrush skills must include rendering specific subject matter in specific illustration styles. Popular subjects include vintage and current model cars, motorcycles, boats, pets, celebrities, generic cartoon figures, exotic and endangered animals, pretty women, sexy robots and beach scenes. Customers often want personalized illustrations of their own cars, pets or other subjects.

For lettering you will be asked most often to render bubble and script lettering styles. As you gain experience, you can learn other styles, such as spike and neon. Just make sure that you can produce all lettering styles quickly, since time is money.

In general, watch trends, particularly in the music industry. For a time someone like Prince is hot, then he is off the scene, maybe to reappear, maybe not. Watch the industry. Who is the hottest female country-western singer? Reba McIntyre? Who is making it big again? Tina Turner?

Illustration styles vary and what sells will be dictated by customer taste. Realistic, highly stylized and graphic, and cartoon-style are three consistently popular looks. Study the work of other artists in your area and those featured in *Airbrush Action* magazine to see what is being done. Consider your own taste and talents and experiment with some of the things you see. See what your customers like by putting a few samples of new styles on display. If they bite, you have a new product. If they don't, put it away. Maybe it will hit big later on when trends and tastes change.

### Basic Business Facts

At some point you may decide to "go for it" and try to make a full-time living as a professional T-shirt artist. When you do, it is important to know the rules of the game so you will avoid any legal or financial hassles.

One of the steps in starting any business is to find an accountant who will help you structure your business. Then, assuming that you are the only owner in the business, you must pay federal, state *and* city income and self-employment taxes on money you earn selling T-shirts. To help minimize the taxes you will owe, keep very meticulous records of your expenses: cost of materials, equipment purchases and maintenance costs, utilities, mileage, business-related postage, promotion and so on. Generally, you can deduct these expenses from your income and lower the amount of money on which you pay taxes. Next, check with your city or county government regarding licenses or permits you may need.

### Availability and Convenience

There are two major rules behind the success of any business. Rule one: The customer has to know about your product. Rule two: You have to make it easy for the customer to buy your product.

Don't expect customers to come to you. If you plan to work out of your home or studio, you need to advertise. Possible methods include advertising in your city or neighborhood newspaper, distributing flyers, hanging posters that show a sample of your art, or placing a listing in the yellow pages. Your budget will determine which avenue you choose. If you want a simpler and cheaper method, word-of-mouth advertising can be effective. Tell your family to tell their friends and ask your friends to tell their fami-

lies. Create sample products for friends and family to wear around town. Your objective is to spread the word as widely as possible. Distribute business cards, too, so that your telephone number is nearby when a customer decides to call you.

## Quality, Time and Pricing

With T-shirt airbrushing, quality and money are functions of time. While you should always produce the highest quality art you can, you must do it within defined time constraints and at a fair cost to the customer.

Pricing is a competitive practice. You don't want to underprice or overprice your work. To find out how much to charge, you will need to research what other artists charge. This is easy to do with a quick, anonymous phone call or a casual, pretend-to-be-a-customer visit to your mall's T-shirt shop. Basically, pricing works this way: You price your shirts close to what the other artists charge and make sure you don't spend more than ten or fifteen minutes on any shirt, unless it is a custom job—a special, unique work for which the client is willing to pay extra. Remember these five tips:

1. People expect the best product they can get for their buck. This can determine whether they come back for your shirts in the future.

2. The secret to making a lot of money spraying shirts is *output*. The more shirts you spray in an hour, the more money you make. If a customer is only willing to pay $10 for an airbrushed T-shirt and you spend two hours spraying the shirt, you will make lousy money. On the other hand, if you can produce six shirts an hour at $10 a shirt. . .well, you figure it out.

3. To plan your output, determine how long it takes you to produce a nice-looking T-shirt. Divide this single-shirt production time into sixty minutes; this is your potential output per hour.

4. There is a limit to what most people will pay for an airbrushed T-shirt, but you can charge more for custom artwork. Base custom charges upon how much time you spend and what you feel the customer is willing to pay.

5. To figure your potential per-hour income, multiply output times customer price.

If you follow these guidelines and price your shirts competitively, you'll get new business, and, more important, customers will come back for more shirts in the future. Make sure your customers walk away happy every time. Give them what they came to you to buy. If someone wants an illustration of a blue giraffe smoking a stogie, as ridiculous as this may seem to you, you should airbrush the best-looking smoking giraffe the world has ever seen.

A shirtboard is essential to hold and flatten fabric for spraying. Good materials for shirtboards are corkboard, cardboard or Masonite.

A clogged paint jar may be the result of allowing your paint to get hot.

# How to Design Stencils

## CHAPTER

A stencil is anything that prevents paint from covering certain portions of a T-shirt. A stencil can be as simple as a strip of masking tape or a french curve, or as intricate as a complex drawing cut out of Pellon or polystyrene.

Artists use stencils for a number of reasons. First, in a commercial setting such as a T-shirt shop, it is the fastest way to produce a "standard" design that you will render over and over for different customers. Second, it is the only way to produce a crisp edge in a T-shirt illustration. Third, if you are painting a large number of shirts with the same image on them, such as for a sports team or a school club, the stencil ensures that each painting looks the same.

In planning "standard" stencil designs for commercial use, make sure that the image will have mass appeal. Sunsets, hearts and cars are consistently popular stencil designs. Being business wise like this will increase the chances that you will reuse the stencil often enough to justify the time you spent cutting it.

### Designing a Stencil

Before you have a go at making your first stencil, read pages 5-6, which describe techniques for turning your ideas into sketches and transferring your sketches onto stencil or fabric material. Select those techniques that best suit your drawing skills and the equipment you have available.

An important objective when planning a stencil is to use minimal lines in your sketch, so you can make your stencil as simple as possible. Too much detail in a stencil will make it flimsy and difficult to manage.

Begin by using simple, easy-to-cut shapes in your sketches. Use common objects such as jar lids, small boxes or cookie cutters. Simply outline these objects, cut along the outline, and remove the unneeded stencil material to expose the area you want to airbrush.

As you grow more comfortable with cutting stencils, you can experiment by cutting more complicated designs, such as for lettering or for a multiple-color illustration. A complex illustration can include many different-sized or unusual shapes, intricate detailing or pattern work, and multiple stencils for more than one color. You have to plan how to cut each stencil in order to end up with the illustration and the special effects you want. It is important to study your illustration and logically group its visual elements—color, shape, pattern, detail, highlights, shadows, lettering and drop shadows—so that when you cut each stencil the grouped elements remain collectively attached. The last situation you want to face is having to reassemble a pile of individual little stencil pieces so they, hopefully, end up looking like the stencil you intended to create.

Some of your stencil designs may require that you cut small pieces, such

as a circle for the sun or the shape of a bear for a wilderness scene. Keep from losing these small pieces by spraying them with a small amount of spray adhesive and sticking or taping them onto the larger stencil pieces from the design. Organize all stencil pieces in large envelopes that are labeled for ease of location.

To keep from spraying beyond the edges of your stencil and onto the shirt surface, allow excess stencil material to cover the areas not to be painted, or, to conserve stencil material, tape heavy paper to the stencil to protect the shirt.

### Working With Positive and Negative Stencils

You must always consider how the positive and negative spaces in your illustration will affect the stencil.

First, it is important to understand the difference between positive and negative spaces. The positive space in an illustration refers to the actual object you are painting; for example, the palm tree in a beach scene is the positive space. The negative space in the same beach scene is the area around the palm tree, which could be the beach, water or sky. The stencil you would cut to *cover* the palm tree is considered a positive stencil. You would expose and spray the (negative) area around the tree and let this spray define the tree's shape. To *expose* the tree for spraying, you must cut a negative stencil that covers the negative space (beach, water, sky) around the tree.

Working with positive and negative stencils becomes trickier as your subject matter or illustration becomes more complicated. Imagine that you want to cut a stencil for the capital letter *P*. In terms of positive and negative spaces, the elements that define

The letter *P* illustrates the problem you'll encounter when cutting a stencil for a shape that has a negative space within it. Obviously, if you cut completely around the negative space opening as shown at the top, it will fall out and you'll end up with a sort of recognizable letter. A better solution, shown at the bottom, is not to cut completely around either the bowl or the negative space, so both elements remain connected and the letter, when sprayed, looks like itself.

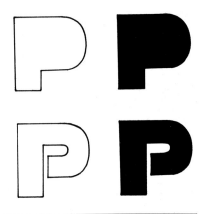

## Using Positive and Negative Stencils

It is important to understand the difference between a positive or negative stencil when you design your stencils.

A *positive* stencil covers the shape of an object; when you spray around the stencil, and then remove it, the paint defines the shape, but the shape remains the color of the fabric. A *negative* stencil covers negative space, exposing an object's shape, to which you apply the paint directly. Removing the stencil leaves the area around the stencil the original color of the fabric (unless you have sprayed some other color there already).

The illustrations below show effects created with positive and negative stencils.

Red is sprayed through a negative stencil.

Red is sprayed through a negative stencil. A positive stencil then covers the red shape, to allow the addition of a drop shadow.

Red is sprayed through a negative stencil. The negative stencil is moved down and to the right to allow the addition of a shadow.

Red is sprayed around a positive stencil.

Red is sprayed through a negative stencil. A positive stencil then covers the red shape, and the background is added.

A negative stencil exposes the arrowhead for painting. A positive stencil then covers the arrowhead, and the sand and shadow are applied.

the *P*'s shape—the stem and the bowl—are the positive spaces; these are the elements to which, typically, you apply color and produce the identifiable *P* shape. The circular area within the bowl is the negative space, which usually is devoid of color. The problem that you will face when designing a *P* stencil (or any stencil with a negative space within a positive space) is how to cut the negative space so you produce, ideally, a single, intact stencil. The diagram on page 27 shows two ways you could cut a stencil for the letter *P*. As already mentioned, the painting process will be most efficient if your illustrations require the fewest number of stencils possible, since a key advantage of the stencil is speed of use.

### Working With Multiple Stencils

When using multiple stencils, registration—that is, the proper alignment of the stencils on the T-shirt—is critical. You must position each stencil so it aligns perfectly with what you have just sprayed. Here are guidelines for registering multiple stencils:

1. Do not use stencils for small details, which can usually be rendered freehand in the form of small dots, lines or taper strokes.
2. Spray the outline (along the edges) of a major stencil first so that other, subsequent stencils can be aligned to this outline.
3. Before spraying any stencil that you have aligned to the subsequent sprayed area, peek under its edges to ensure you have aligned it correctly.
4. If, after spraying, you find the registration is slightly off, simply spray a little color into the unsprayed area.
5. Carefully remove each stencil: With one hand, press the fabric flat to the shirtboard as you gently ease the stencil up with your free hand. Careless removal will guarantee that the fabric will move and stretch, distorting what you have sprayed and making registration of the next stencil impossible.

## Stencil Material

Stencils can be made from high-impact .020-mil polystyrene plastic, 10-mil acetate or mylar (clear or opaque), Pellon, light-weight cardboard, posterboard, masking tape and, sometimes, paper. You can buy precut stencils, usually for lettering, at art supply stores. To enjoy ultimate creative freedom, however, you should design and produce your own stencils.

Polystyrene is a very popular choice for stencil material. Its durability allows the T-shirt artist to use stencils cut from this material over and over. As paint builds up on the stencil you just peel the paint off.

Acetate is easy to trace illustrations onto, but it is expensive.

Heavy-weight Pellon is a good, multi-faceted material that absorbs paints and prevents build-up on the mask. Available from airbrush supply houses and sometimes from screen printing companies, Pellon is durable, long-lasting and relatively inexpensive. Avoid the light-weight Pellon used in sewing; it will not hold up. In addition to stencils, Pellon is useful for test spraying and as a surface for sample artwork.

Posterboard and cardboard (avoid the corrugated type) are inexpensive, widely available and easy to cut. Some artists prefer posterboard to plastic, because they know they will update their standard designs long before the posterboard wears out. Masking tape is useful for small areas, straight lines, or to patch a miscut or torn stencil. Light-weight paper, although inexpensive, is suitable for one-time use only, because it becomes wet once paint is sprayed onto it.

### Loose Objects as Stencils

French curves, circle templates, cotton, lace, feathers, leaves, hand-torn paper, and other tools and objects offer interesting stenciling options. Use them in the same way as any other stencil.

## How to Cut Stencils

A no. 11 or 16 (the latter is more durable) X-Acto blade and knife combination is the best cutting tool for any stencil material because of the control and ease with which it cuts. Sharp fabric scissors are good for cutting Pellon, and a stencil burner is outstanding with acetate, plastic and Pellon. The stencil burner (retail cost about $25) is used by professional illustrators regularly. The burner melts the area of a stencil it touches using 700 to 800 degree heat. It has a very sharp tip that produces small holes and irregular shapes much quicker and easier than a knife blade can. Ideally, place your drawing on a glass-topped light table (most surfaces other than glass will be affected by the stencil burner's heat), put the stencil material on top, and then use the stencil burner.

## How to Stick Stencils Onto Fabrics

To adhere a stencil to a T-shirt, spray the back of the stencil with a light coat of spray adhesive. Do not use industrial or construction grade adhesive, which can create a permanent bond. You can restick the stencil many times before you will need to recoat it. Avoid using adhesive-backed stencils on leather, which can end up smudged. Be careful when using spray adhesive with thin or intricately cut stencils; you may find it difficult to remove the stencil from the shirt without tearing the stencil.

You can handhold a stencil to fabric, too, if you do not use your free hand to support your airbrush. (Many artists find that they have better spray-

ing control if they control the airbrush trigger with one hand and the paint jar with the other hand.) If you do handhold a stencil, you will probably discover that it is hard to achieve crisp edges, because you cannot press all of the stencil edges tightly to the surface. Odds are you will get paint underspray beneath the stencil edges.

The third application option is to use low-tack masking or white artist's tape, securing all four corners of your stencil to the shirt. For more complex stencils with unusual shapes or cuts that tend to arch away from the fabric, roll a piece of tape into a cylindrical form, stick it to the back of the problem area of the stencil, and then attach the stencil to the shirt.

To prevent underspray, regardless of the sticking method you use, make sure you hold the brush perpendicular to the spraying surface and begin by outlining along the edges of the stencil.

## Using Handheld Stencils

You do not always have to adhere a stencil to your painting surface. Sometimes it may be easier and faster to handhold it, or the stencil may be something with dimension that you simply cannot stick to the fabric. Handholding a stencil lets you vary the edge quality you produce. The closer the stencil is to the fabric, the crisper the edge will be. You can also produce patterns by spraying through a handheld stencil, repositioning it slightly, spraying again, repositioning, and so on. Your choice of handheld stencils is limited only by your imagination: french curves, circle templates, window screening, cheesecloth, jar lids and torn paper are a few possibilities.

This pattern was created from a custom-designed stencil.

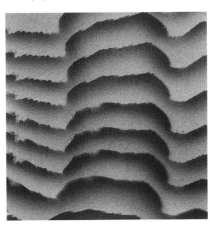
Torn paper was held at various heights.

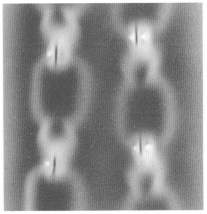
Steel chain created this effect.

A french curve produced this effect.

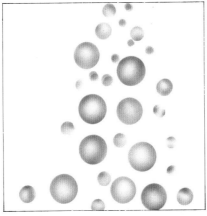
A circle template produces bubbles. Make sure to cover unwanted holes on the template with masking tape to prevent unwanted bubbles.

An airbrush paint jar lid produced this circular effect.

# Airbrushing With Stencils

## CHAPTER

Using stencils to create T-shirt illustration does not require a real mastery of the airbrush. The stencil, for the most part, determines how and where the paint hits the fabric. The beginning artist, using a simple stencil, can achieve amazing results. As you become more skilled, you will find that stencils enable you to produce a sharp line quality, prevent overspray, and dramatically increase the speed at which you produce illustrations.

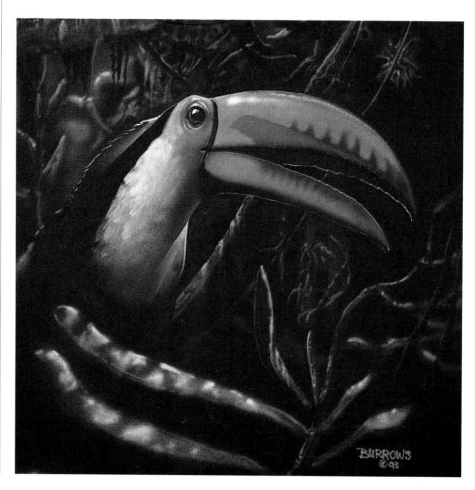

# AIRBRUSHING SHAPE, SHADING AND HIGHLIGHT

**Materials:** T-shirt or practice fabric; X-Acto knife and no. 11 or 16 blade; Pellon or other stencil material; adhesive spray mount
**Acrylic Fabric Paint:** Purple or any color of your choice
**Number of Stencils Cut:** One

**TECHNICAL NOTE:** As when using any stencil, prevent underspray beneath the stencil by first holding the airbrush perpendicular to the fabric, and outlining the image around the edges.

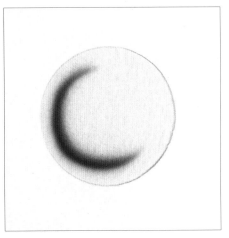

### Step One
Cut a circle (see template on page 109) out of your stencil material. Lightly coat the back of the stencil with adhesive spray mount. Make sure to apply an even coating along the stencil edges to keep paint from getting beneath the stencil. Position the stencil on your fabric. Holding the airbrush about 1 inch from the surface, spray the curved, purple reflection line, placing it at a 45 degree angle from the sphere's center and 1/2 inch from the lower stencil edge.

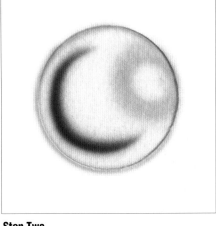

### Step Two
With the airbrush 2 to 3 inches from the surface, spray along the entire edge of the sphere to begin to define its shape. Lightly spray the circular highlight shape opposite the linear reflection.

### Step Three
Begin filling in the sphere by spraying a light coat of color, starting at the outer edge and working in circular motions toward the highlight. Define the highlight, but do not spray inside it.

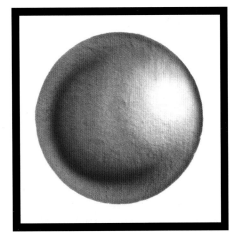

### Step Four
Gradate the color from the outer edge toward the highlight by applying three consecutive coats of paint. (See pages 8-11 for information about gradating color.) Each coat should begin at the outer edge and move toward the highlight. To achieve the gradation, you must remember to end the first coat about 1/2 inch from the highlight, the second coat 1 inch from it, and the third coat 1 1/2 inches from the highlight. Remove the stencil and heat-set the illustration.

# USING OVERSPRAY TO BLEND COLORS

**Materials:** T-shirt or practice fabric; X-Acto knife and no. 11 or 16 blade; Pellon or other stencil material; adhesive spray mount
**Acrylic Fabric Paint:** Blue, magenta and yellow
**Number of Stencils Cut:** One

**TECHNICAL NOTE:** Between steps one, two and three you will reposition the stencil and realign it with the edges of the sprayed area. To ensure that you can align the edges perfectly, spray the *back* of your fabric with a light coat of spray mount, and gently press the fabric to your shirt-board. This will keep the fabric from moving as you reposition the stencil.

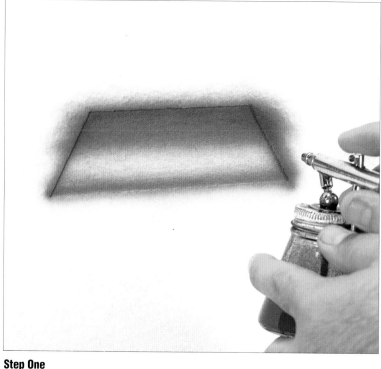

**Step One**

Cut the irregular shape (see page 110) out of your stencil material. Apply an even coat of adhesive spray mount. Position the stencil parallel to the bottom edge of your fabric. Spray blue around the edge of the shape, applying several light coats of color until the area is an intensity that you like.

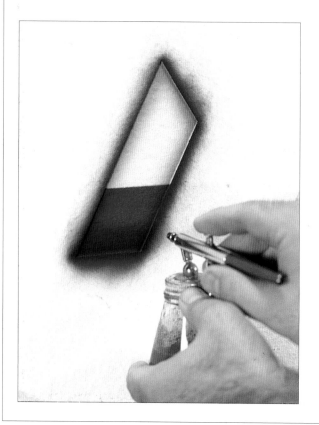

**Step Two**

Remove the stencil and rotate it clockwise as shown, fitting the corners of the stencil and the blue painted area together. Repeat the spraying procedure from step one, using magenta. Overspraying blue with magenta will create purple.

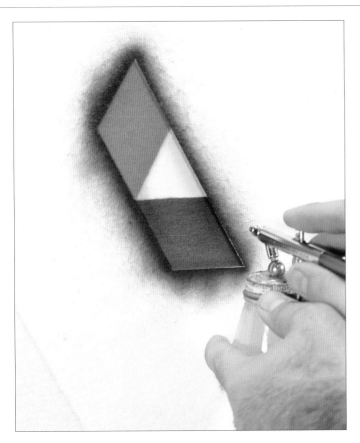

**Step Three**
Reposition the stencil as you did in step two. Ensure that the painted area and the stencil corners align. Repeat the spraying procedure from step one, using yellow. Overspraying yellow on the magenta corner will create orange, and yellow on the blue corner will create green.

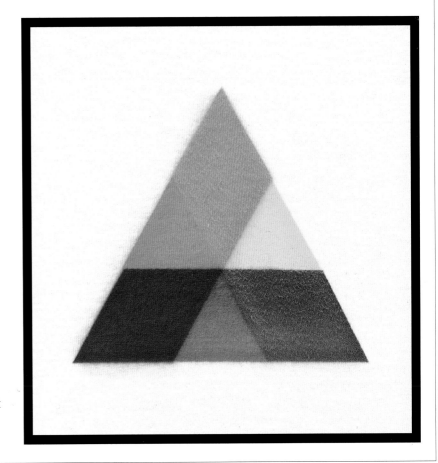

**Step Four**
Remove the stencil to expose the six-colored triangle that you rendered using only three colors. Heat-set the illustration.

# GRADATING COLOR TO CREATE A 3-D EFFECT

**Materials:** T-shirt or practice fabric; X-Acto knife and no. 11 or 16 blade; Pellon or other stencil material; adhesive spray mount
**Acrylic Fabric Paint:** Red and white
**Number of Stencils Cut:** Two

**TECHNICAL NOTE:** You will use negative stencils to render this illustration. (See pages 27-28 for information about positive and negative stencils.)

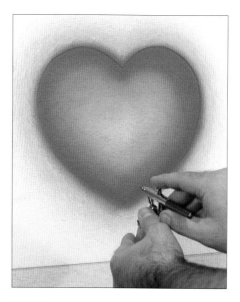

### Step One

Cut the two heart shapes (see page 111) from your stencil material. Apply a light, even coat of adhesive to the back of the stencil. Position the stencil on your fabric. Spray a wide, even band of red around the heart opening by holding the airbrush about two inches from the surface and pulling the trigger back about three-quarters of its moving distance. Note that some of the red overspray in the center of the heart will create a pink tone.

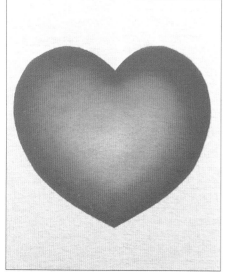

### Step Two

Gradate red from the outer edge inward. Follow the heart's contour and apply multiple coats to build up the color's density.

### Step Three

Lightly coat the back of the highlight stencil with spray adhesive. Leave the heart stencil in place and position the highlight stencil over the red, sprayed heart. (The spray mount will not affect the red paint.)

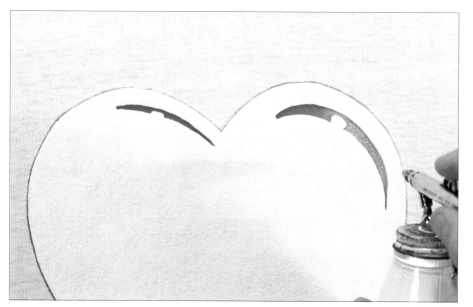

**Step Four**

Spray at least three light coats, *not* a single heavy coat, of white to create highlights with crisp edges and even color. Begin each application by spraying in the middle of each highlight and gradating the color as you move toward both ends. (See pages 7 and 11-15 for information on spraying highlights and pages 8-11 for information on gradating color.)

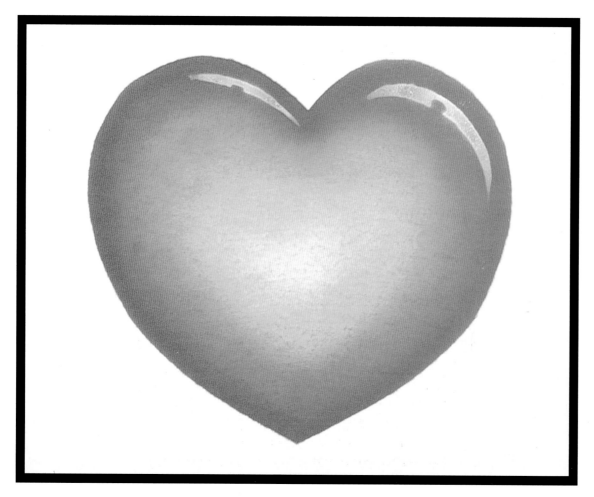

**Step Five**

Remove both stencils. Heat-set the illustration.

# AIRBRUSHING STENCILED SCRIPT LETTERING

**Materials:** T-shirt or practice fabric; X-Acto knife and no. 11 or 16 blade; Pellon or other stencil material; adhesive spray mount
**Acrylic Fabric Paint:** Red, white and black
**Number of Stencils Cut:** Three

**TECHNICAL NOTE:** For this illustration you can use the heart you created in the previous project, Gradating Color to Create a 3-D Effect, or render a new heart, using the directions for that project. Also, you can airbrush any name on the heart that you like.

**Step One**
Follow the steps in the previous project to create the heart illustration.

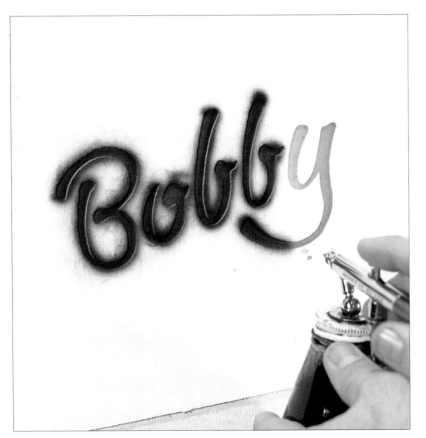

**Step Two**
Cut the name Bobby (see page 112) from your stencil material. Apply a light, even coat of adhesive spray mount to the back of the stencil. Center the stencil on the heart. Spray an even, dense coat of black over the name stencil, holding the airbrush perpendicular to the fabric.

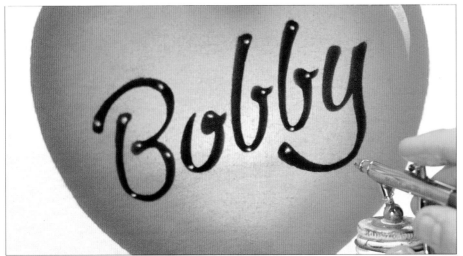

### Step Three

Remove the stencil. Freehand highlights and add sparkle to the name by spraying white dots on the lettering, as shown. Typically, highlights are placed on the ends and curves of each letter.

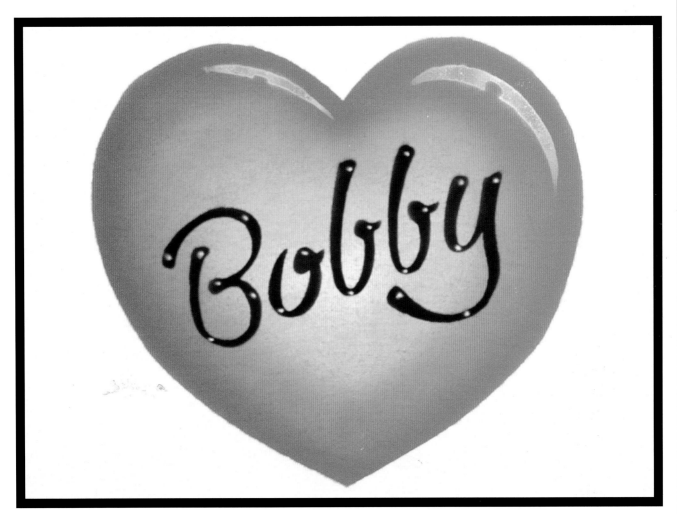

### Step Four

Heat-set the finished illustration, which has a three-dimensional quality.

# RENDERING DIMENSION AND FORM

**Materials:** T-shirt or practice fabric; X-Acto knife and no. 11 or 16 blade; Pellon or other stencil material; adhesive spray mount
**Acrylic Fabric Paint:** Red, black, brown and white
**Number of Stencils Cut:** Two

**TECHNICAL NOTE:** When you reposition stencils in this project you may notice that you cannot get the stencil edge to align perfectly with a painted edge. This problem indicates that the fabric shifted when you removed a previous stencil. To fix the problem, lift the misaligned area of the stencil, but do not remove the entire stencil. Gently pull the fabric until you see that the painted edge aligns with the stencil edge, then pat the stencil so it adheres to the fabric. Repeat this process for all edges that do not align.

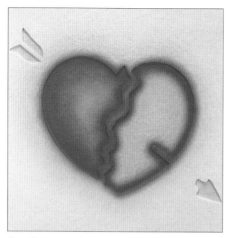

**Step One**
Using one of the techniques described in chapter one, transfer the drawing from page 113 onto your stencil material. Cut along all of the drawing lines and separate the stencil pieces. Apply a light, even coat of spray adhesive to the back of the heart stencil. Position the stencil on the fabric. Spray the edges of the heart an intense red by holding the airbrush 1 to 2 inches from the fabric and moving the trigger one-half to three-quarters of its moving distance. Then, move the airbrush 2 to 3 inches from the surface, hold the trigger in the previous position, and spray a light coat to color the entire heart.

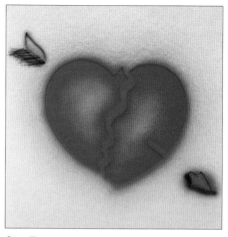

**Step Two**
Apply a light coat of black to add a gray tone to the arrowhead and feathers.

**Step Three**
Create feather textures using the taper stroke.

**Step Four**
Add a darker tone to one edge of the arrowhead to give it a three-dimensional quality.

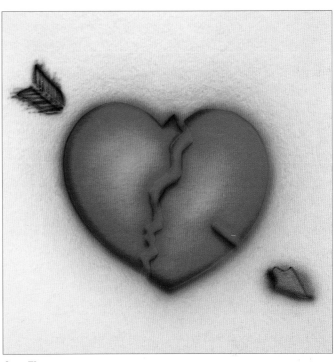

**Step Five**
Shade the bottom and the left edges of the heart with black.

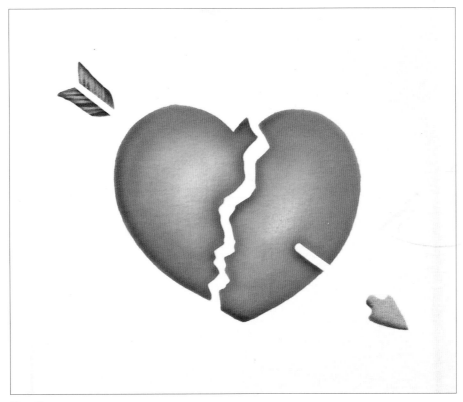

**Step Six**
Remove the stencil.

### Step Seven
Position the arrow stencil and spray the arrow's shaft brown. Spray the white highlights. Using black, add shading to the shaft and spray the arrowhead's details.

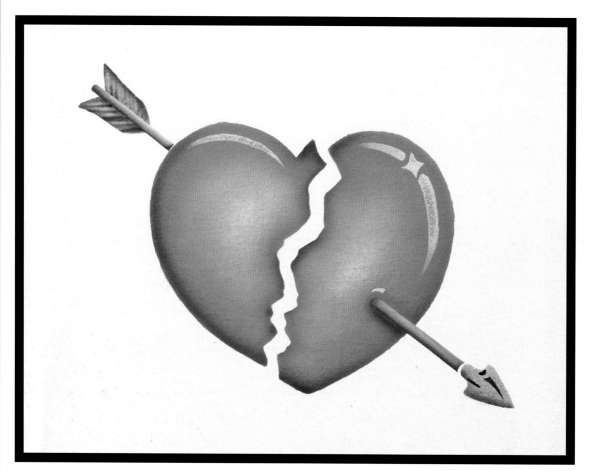

### Step Eight
Remove the stencil and heat-set the illustration.

# WORKING WITH INTRICATE STENCILS

**Materials:** T-shirt or practice fabric; X-Acto knife and no. 11 and 16 blade; Pellon or other stencil material; adhesive spray mount
**Acrylic Fabric Paint:** Black, orange, green, pink, brown and white
**Number of Stencils Cut:** Three

**TECHNICAL NOTE:** Notice in step five that you leave the area around the eye white, using the same technique you used to spray the circular highlight in the first project in this chapter.

Remember that with this, and most illustrations in this book, you can spray different colors of fabric paint, which are transparent, over previously sprayed black paint without affecting the black color. (The exception is white, which is opaque and *will* affect black.)

The drop shadow featured here requires a very light application of black. Generally, you need to hold the brush about 1 inch from the fabric and pull the trigger back *only* one-quarter of its moving distance to create a light mist.

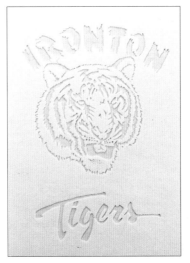

**Step One**
Transfer the drawing on page 114 to your stencil material. Cut and separate the individual stencil pieces. Apply a light, even coat of spray adhesive. Position the stencil for the black areas on the fabric.

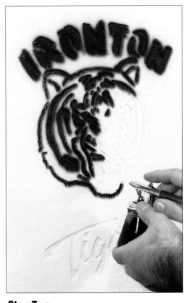

**Step Two**
Fill in all open areas completely with black.

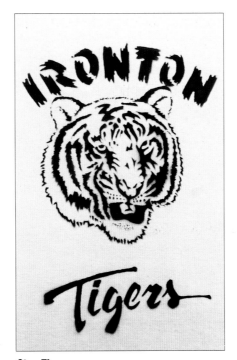

**Step Three**
Carefully remove the stencil.

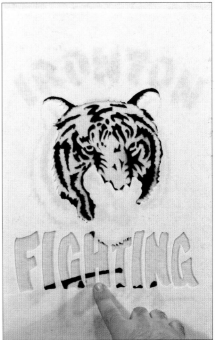

**Step Four**
Position the stencil for the orange areas, carefully lining it up with the black painted areas.

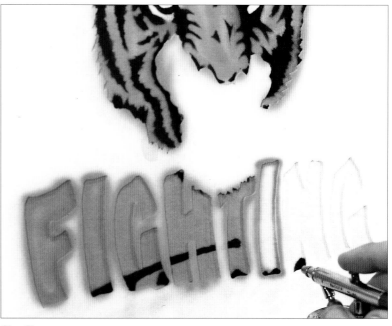

**Step Six**

Spray orange heavily to outline the letters of the word *FIGHTING*, then fill them in with a light coat of orange to create dimension.

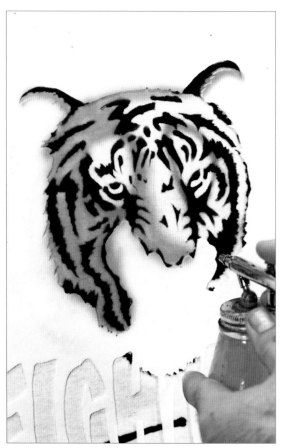

**Step Five**

First, lightly spray a circular orange line around the eye areas, which you should leave white. Fill in the remaining areas with orange, being careful not to spray the white areas in and around the eyes. You can spray directly over the black paint that is already on the fabric.

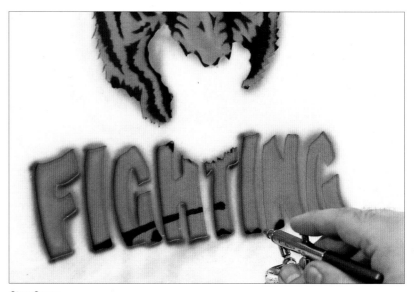

**Step Seven**

Shade the left and bottom edges of the letters with brown.

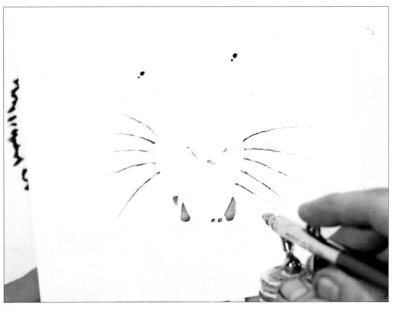

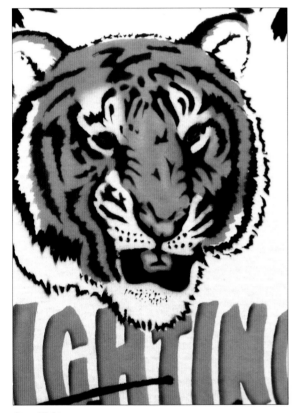

**Step Nine**

Position the whisker and detail stencil. Apply a few light coats of white to the teeth, whiskers and highlights. Remember to use *light* coats, which will achieve a brighter white and crisper edges than a single, heavy coat will.

**Step Eight**

Carefully remove the orange stencil. Freehand the nose and tongue pink, holding the airbrush ½ inch from the surface and pulling the trigger back only one-half of its moving distance. Spray pink heavier around the edges to simulate shading. Freehand the eyes green.

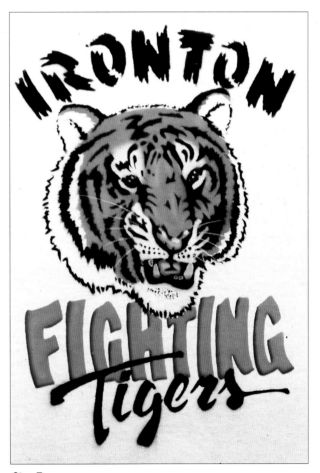

**Step Ten**

Remove the stencil.

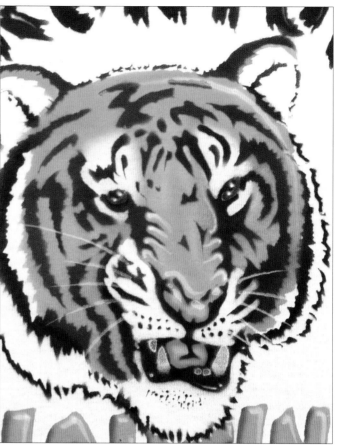

**Steps Eleven-Thirteen**

Freehand white highlights on the lettering and on the tiger, as you desire.

**Step Fourteen**

Add soft shadows to create a three-dimensional effect. Render these shadows by freehand-ing black lightly to the lower left areas of *IRONTON* and *TIGERS*, and to the face.

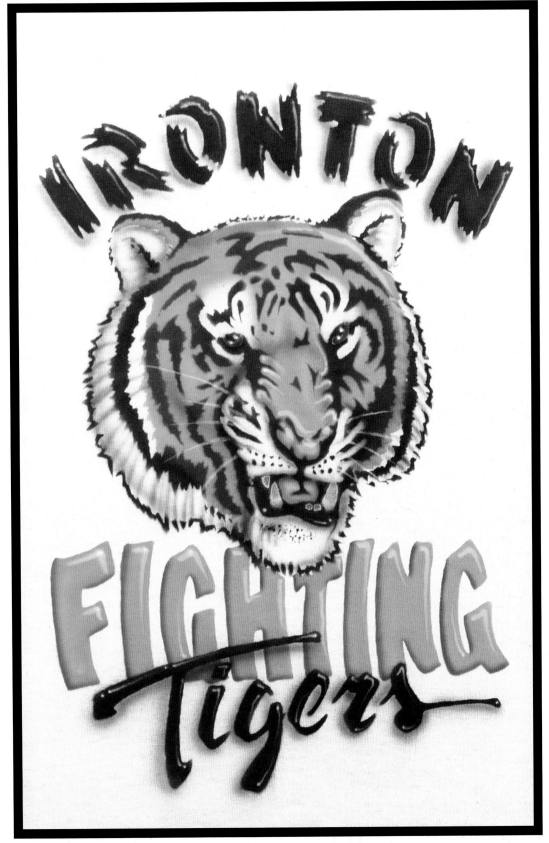

**Step Fifteen**
Spray black taper strokes around the face to add texture. Heat-set the illustration.

# COMBINING LETTERING AND ILLUSTRATION

**Materials:** T-shirt or practice fabric; X-Acto knife and no. 11 or 16 blade; Pellon or other stencil material; adhesive spray mount
**Acrylic Fabric Paint:** Red, yellow, black and white
**Number of Stencils Cut:** Three

**TECHNICAL NOTE:** The transparency of fabric paint lets you blend two colors, such as red and yellow, to create a third color, orange. By blending colors successively, such as in the lettering and the squiggle in this project, you can produce a gradation effect with more impact than with a single gradated color.

**Step One**
Transfer the drawing from page 115 to your stencil material and cut the stencils. Apply a light, even coat of spray adhesive to the back of the *'VETTE* stencil and position the stencil on the fabric. Spray the top three-quarters of *'VETTE* and the edges of the squiggle with red. Fill in the remaining portion of *'VETTE* and the squiggle with yellow, blending the color into the red.

**Step Two**
Apply a light coat of black to the edges of *'VETTE*.

**Step Three**
Shade the bottom edge of the squiggle with black. Spray the tires with a light coat of black to produce a gray tone.

**Step Four**

Remove the stencil.

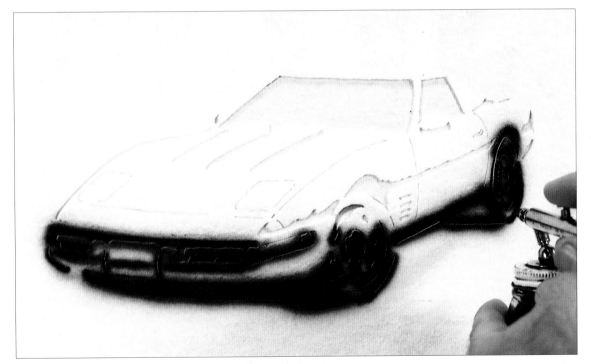

**Step Five**

Position the car's shadow stencil, and spray everything solid black except the windows. Outline the window edges with black, then lightly shade them with black to create a gray tone.

**Step Six**

Remove the stencil.

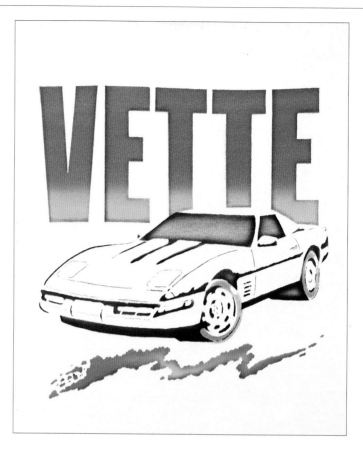

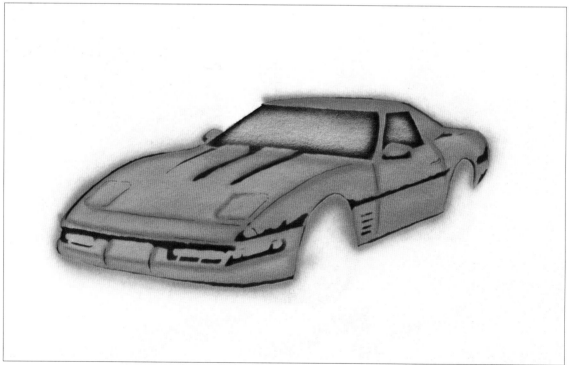

**Step Seven**

Position the car body stencil and, using red (or any color), fill in the entire stencil with a light coating. Apply more intense areas of the same color by moving the brush closer to the fabric. This will create shading and reflections.

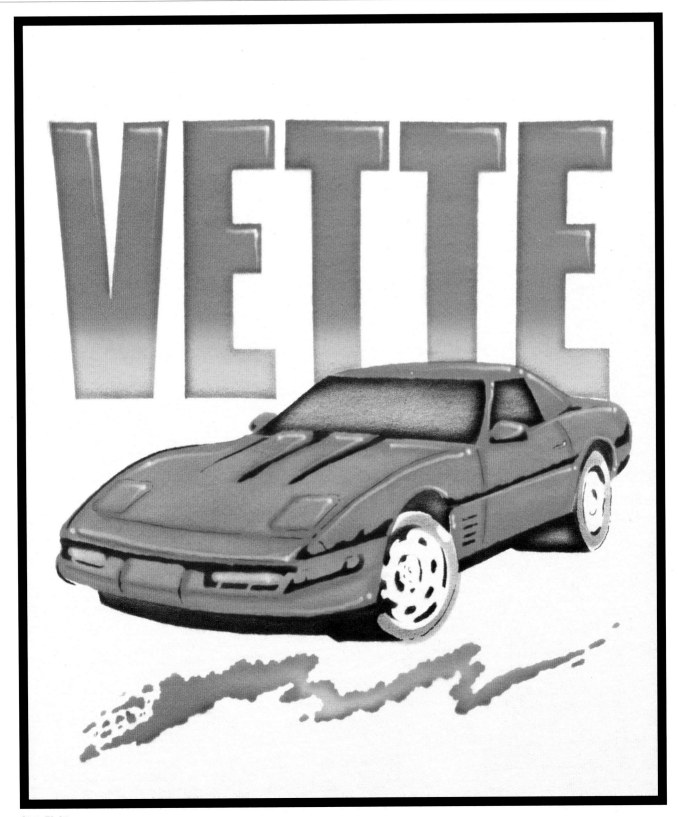

**Step Eight**
Remove the stencil. Freehand white highlights using the taper stroke. Heat-set the illustration.

# AIRBRUSHING DETAIL, FLESH TONES AND DROP SHADOWS

**Materials:** T-shirt or practice fabric; X-Acto knife and no. 11 or 16 blade; Pellon or other stencil material; adhesive spray mount

**Acrylic Fabric Paint:** Yellow, green, black, red, brown, orange and white

**Number of Stencils Cut:** Four

**TECHNICAL NOTE:** Notice in steps four and eleven that you will need to spray the color very lightly, using multiple coats of paint. Spraying a heavy application requires more air pressure and you'll risk overspraying red onto the surrounding illustration.

**Step One**

Transfer the drawing from page 116 onto your stencil material. Cut along all of the drawing lines and separate the stencil pieces. Apply a light, even coat of spray adhesive to the back of the background stencil and position it on your fabric. Spray yellow, adding a heavier coat around the edges.

**Step Two**

Outline the background stencil with green.

**Step Three**

Spray a black drop shadow along the lower left side of the character, holding the brush about 3/4 inch from the fabric.

**Step Four**

Spray several light coats of red on the loincloth and the character's mouth.

**Step Five**
Remove the background stencil.

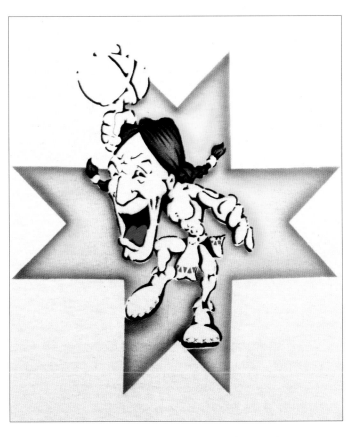

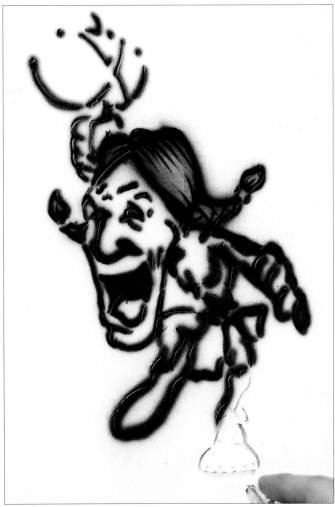

**Step Six**
Position the character detail stencil and spray solid black on all exposed areas, *except* the hair. Add shading to the hair by outlining only this area's edge with black. Add texture to the hair using the taper stroke.

**Step Seven**
Remove the stencil.

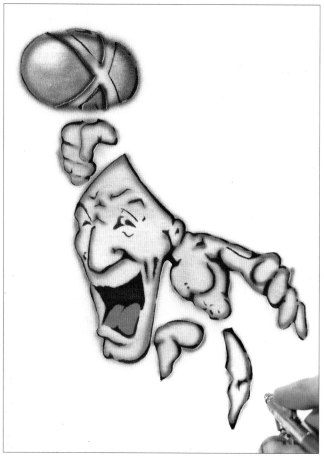

### Step Eight

Position the body and tomahawk stencils. Spray a light coat of black over the tomahawk to give it a gray tone; leave the highlight area unsprayed. Shade the body by spraying brown heavily around the edges then lightly filling it in.

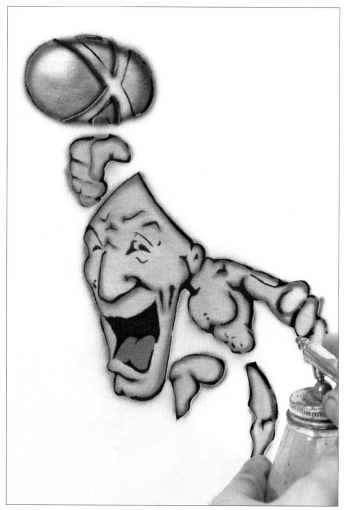

### Step Nine

Tint the skin with a light application of orange.

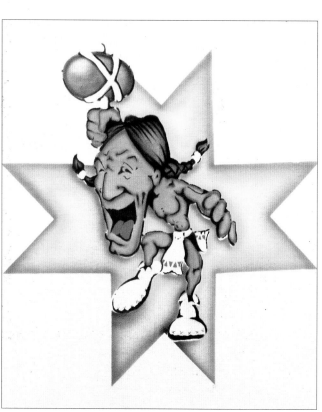

### Step Ten

Remove the stencil.

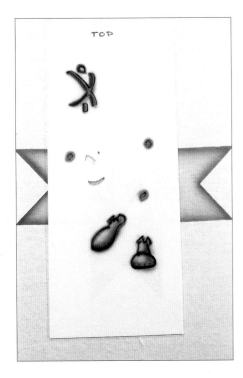

**Step Eleven**

Position the moccasin and detail stencil. Paint the teeth, war paint and eye areas white using a few light applications of paint, rather than one heavy one. Spray the hairbands and waistbands red. Spray the tomahawk handle and laces and the moccasins brown, applying heavier color around the edges for shading.

**Step Twelve**

Remove the stencil. Add a drop shadow to the tomahawk and hand. Freehand white highlights using the techniques on pages 7 and 11-15. Heat-set the illustration.

# USING MULTIPLE STENCILS

**Materials:** T-shirt or practice fabric; X-Acto knife and no. 11 or 16 blade; Pellon or other stencil material

**Acrylic Fabric Paint:** Light blue or aqua, pink, yellow, black and white

**Number of Stencils Cut:** One main stencil, cut into twelve pieces to fit together like a puzzle.

**TECHNICAL NOTE:** Throughout this project you will remove and reposition stencils, which will require that you carefully register or realign the stencils over already painted image areas. If you are not careful when aligning stencils you will end up with white gaps between painted areas in the image, the result of not placing a stencil edge directly next to a previously painted edge.

## Step One

Transfer the drawing on page 117 to your stencil material using one of the sketch transfer techniques described on pages 5-6. Lightly cut along all of the sketch lines to create the various stencil pieces that will produce this illustration. Separate these stencil pieces. Apply a light, even coat of adhesive spray mount to the back of each piece and then put them all back together on your fabric. Make sure the edges fit tightly but do not overlap.

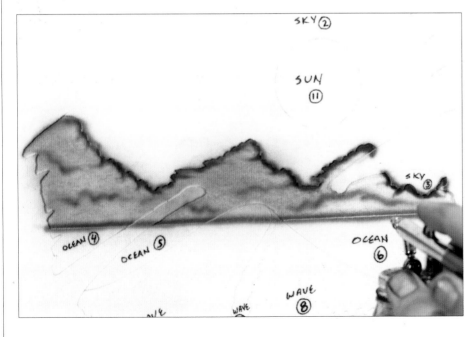

## Step Two

Remove stencil piece 1 (clouds). First outline the edge of the exposed area with light blue or aqua, and then spray a light coat of the same blue overall, holding the airbrush about 2 inches from the fabric. To add texture to the clouds, move the brush within 1/2 to 1 inch of the fabric and apply heavy texture lines of the same blue.

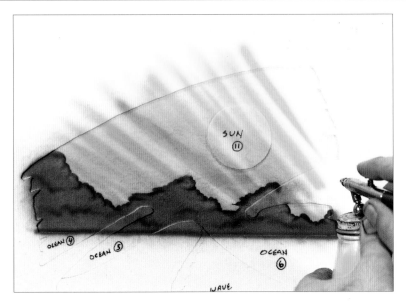

### Step Three

Remove stencil pieces 2 and 3 (sky). Spray a light coat of pink over the blue cloud area. Add diagonal pink and yellow streaks, overlapping the center streaks to produce orange ones.

### Step Four

Reposition piece 1 and remove pieces 4, 5 and 6 (ocean) and spray the edges with light blue or aqua. Add the horizontal lines across the ocean areas to create the textural effect of distant waves.

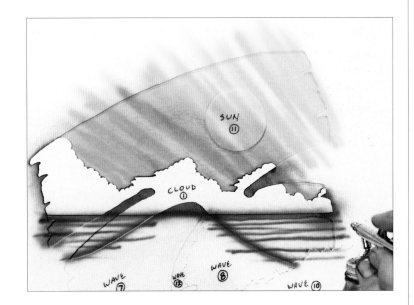

### Step Five

Spray pink and yellow reflections in the ocean beneath the pink and yellow sky sections.

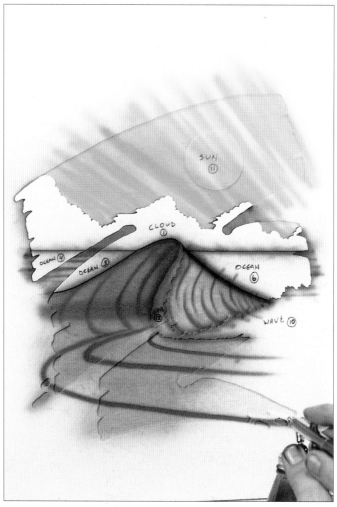

**Step Six**

Carefully reposition pieces 4, 5 and 6. Remove pieces 7, 8 and 9 (waves). Add the curving lines. Notice how these lines taper off. (See page 14 to learn how to airbrush a taper stroke.) Spray light blue or aqua to tone the wave; add a darker tone to the wave's inside shadow area.

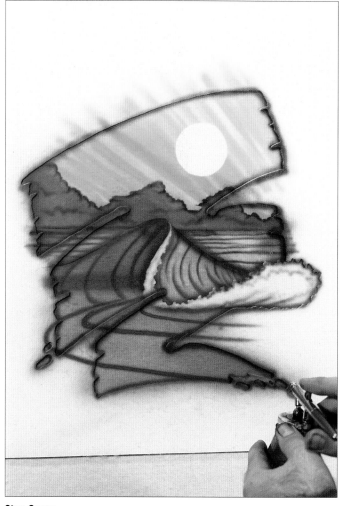

**Step Seven**

Remove *all* of the remaining inside stencil pieces, leaving the main stencil in place. Shade the wave's foamy section (pieces 10 and 12) and the entire outer edge of the illustration with light blue or aqua.

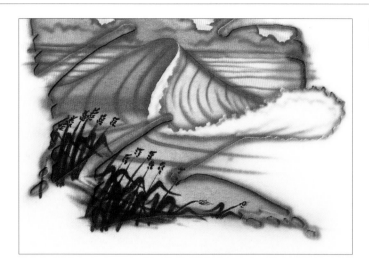

**Step Eight**
Freehand sea oats with black using taper strokes.

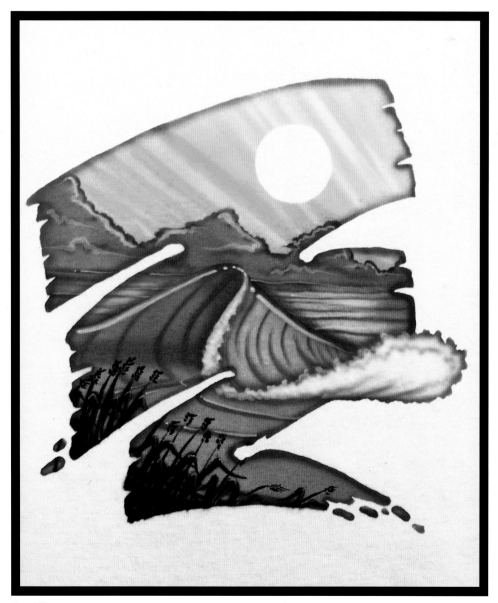

**Step Nine**
Remove the main stencil and add white highlight lines as desired. Heat-set the illustration.

# COMBINING MULTIPLE LETTERING STYLES

**Materials:** T-shirt or practice fabric; X-Acto knife and no. 11 or 16 blade; Pellon or other stencil material; adhesive spray mount
**Acrylic Fabric Paint:** Black, brown, light blue or turquoise, white and red
**Number of Stencils Cut:** Three, plus one hand-held straightedge

**TECHNICAL NOTE:** The main characteristic of a metal effect is reflectivity, so you will typically see metal illustrated to reflect sky (blue) and ground (brown) colors. In addition, bisecting the middle of the metallic letters is a horizon line. Finally, white highlights are added for sparkle.

Notice that all of the letters in *HEAVY* are designed with a horizontal line cut through them. The letter *A* needed this design in order to allow for the negative space within the letter; the remaining letters were designed to appear consistent with the *A*.

**Step One**
Transfer the sketch on page 118 to your stencil material. Separate the individual stencil pieces. Apply a light, even coat of spray adhesive to the back of the *HEAVY* stencil and position it on your fabric. Spray a very light coat of black over the lettering.

**Step Two**
To give dimension to the lettering, apply a light coat of black to darken only the left side and lower edges of the top and bottom letter areas, holding the airbrush 1/4 to 1/2 inch from the fabric.

**Step Three**
To create the horizon line, first use your X-Acto knife and a metal straightedge to make a clean, straight cut in a piece of Pellon large enough to cover the lettering. This Pellon will be your straightedge stencil. Position the Pellon straightedge so it covers the top one-half of the word *HEAVY*. Begin spraying a heavy line of brown along the Pellon edge, gradating it downward no more than three-quarters of the distance to the bottom of the letters.

**Step Four**

Remove the straight-edge Pellon, leaving the *HEAVY* stencil in place.

**Step Five**

Using light blue or turquoise, spray a heavy line of blue along the top of the letters and gradate the color toward the brown horizon line. Do not worry about the blue overspraying the brown; the overspray will not show.

**Step Six**

Moving the brush quickly, spray white reflection lines diagonally across the lettering by holding the airbrush 1/2 inch from the fabric and pulling the trigger three-quarters of its moving distance. Be careful to keep spacing consistent between the lines.

**Step Seven**

Remove the *HEAVY* stencil, being very careful not to move the fabric.

**Step Eight**

Position the *METAL* stencil over the painted *HEAVY*. Spray red heavily around the outside of all the letters, then mist red over each letter to create dimension.

**Step Nine**

Remove the *METAL* stencil.

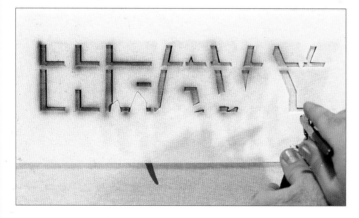

**Step Ten**

Position the *HEAVY* drop shadow stencil, manipulating the fabric if edges do not align. Mist black to create a medium-to-dark gray tone in the shadow.

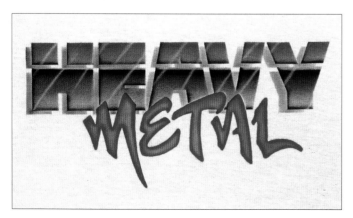

**Step Eleven**

Carefully remove this stencil. The hard-edge shadow will create the illusion that the lettering is raised on the fabric.

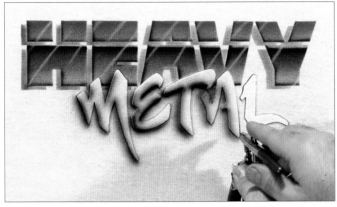

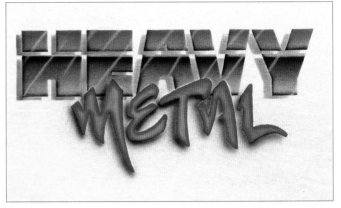

**Step Twelve**

Position the individual letters that you extracted from the *METAL* stencil over the painted letters. Spray in the drop shadow with black, matching the gray tone to that of the *HEAVY* drop shadow.

**Step Thirteen**

Remove the letter stencils. The soft-edged shadows around *METAL* will make it appear to be raised above *HEAVY*.

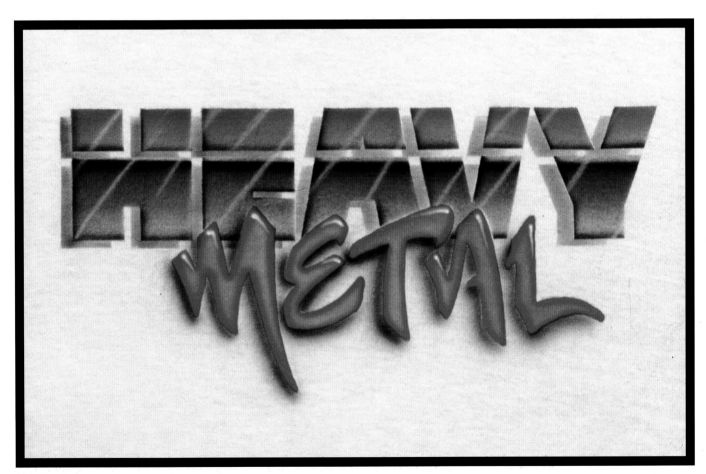

**Step Fourteen**

Add white highlights on *METAL* opposite the drop shadows. Notice how the two different textures and the drop shadows add the sense of dimension to the illustration. Heat-set the illustration.

# PROFESSIONAL PORTFOLIO

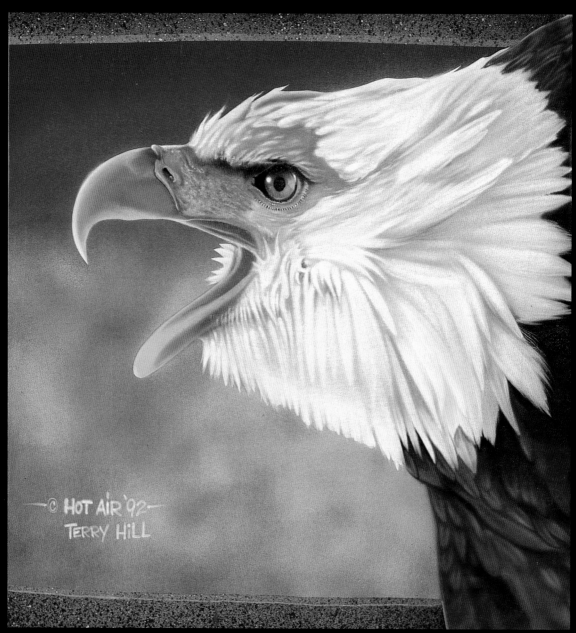

Top professional T-shirt artists know when to use stencils in order to make their illustrations stand out. In this piece, the eagle is totally freehanded, but a stencil of wax paper covered the eagle while the background was sprayed. The stencil guaranteed that overspray didn't muddy the intricate shading in the feather texture. To render the textures, the artist used many shades of blue and purple underpainting, which makes the white feathers look whiter. A small amount of yellow underpainting adds an early morning light quality.

*Artist: Terry Hill*

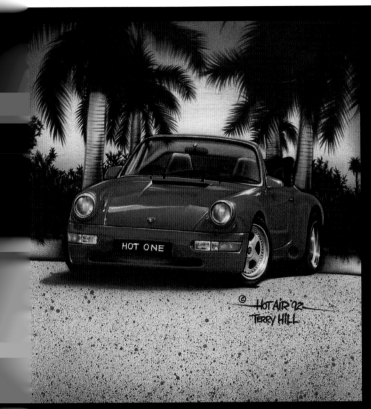

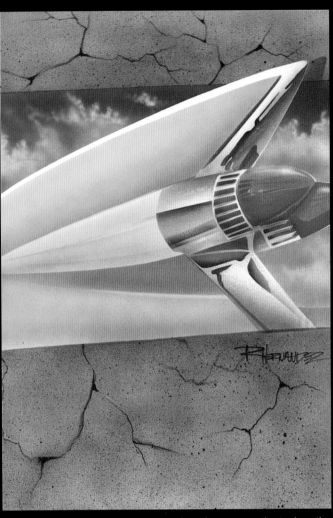

In beach locations, custom illustrations of customers' cars typically include a traditional beach scene. The artist composed this image using a non-traditional, more elegant beach scene background. Once the background was in place, the wax paper stencil protecting the car was removed. The challenge with the car's surface was to make the blue look wet, which the artist achieved by using extreme contrast between the lights and the darks, and by using a vibrant blue color. The drop shadow beneath the car and the subtle, dark gradation in the foreground accentuate the car's form.

*Artist: Terry Hill*

The artist used strong color contrast and a unique perspective to draw the viewer's eye to this completely stenciled custom illustration. Gentle color gradation produces subtle changes in the car's surface. The artist created the stipple effect of the granite wall using the clothespin technique described in the Don Ashwood illustration on page 69.

*Artist: Rich Hernandez*

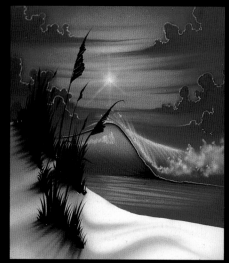

This blue-tone, moonlit scene is most popular with male customers, who are not attracted to the more colorful sunset beach scenes. (Men are attracted, typically, to blue color schemes, while women tend to prefer purple and pink.) The only stencil used was for the sand dune, in order to keep it pristine and white. This design is very paintable by beginning T-shirt artists because it uses many of the basic airbrush elements: taper and squiggle strokes, shading and the starburst effect.

*Artist: Don Ashwood*

The remarkable aspect of this stenciled piece (stencils were used to create the triangular framework for the unique zebra texture and the basic lettering shape) is the *Spring Break* lettering, currently the hottest style on the Florida tourist scene. To produce this style, the artist airbrushed the lettering six times. The first step requires outlining the lettering in black using a stencil. Each subsequent step then alternates between freehanded color shading and outlining. The entire illustration takes only eight and a half minutes to render.

*Artist: Don Ashwood*

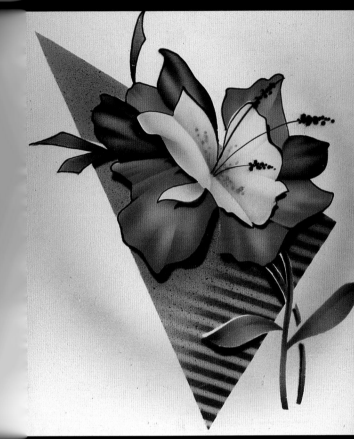

This classy, feminine design is usually bought by—or as gifts for—older women because of the pink-purple color scheme and the subject. Stencils are handheld to paint the soft-edged outer and inner flower shapes. The crisper triangular shape results from a stencil adhered to the fabric. A soft vignette effect draws the viewer's eye to the flower, the point of interest.
*Artist: Don Ashwood*

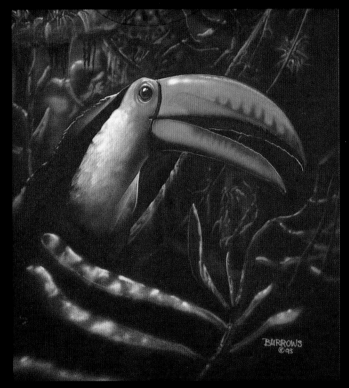

To create the three-dimensional effect in this illustration, the artist first sketched the image using white chalk. After covering the bird with a wax paper stencil, he cut around the bird to expose the background, which he rendered until it was 80 percent complete. After removing the stencil, he began work on the toucan, working back and forth between the bird and the background; this approach let him build the lights and shadows, and the resulting depth in the image.
*Artist: Steve Burrows*

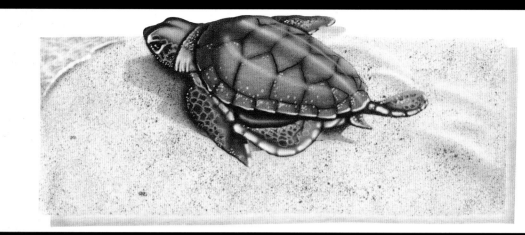

This image plays off of the popularity of environmental concerns, particularly endangered species. Notice how the border does not completely encompass the illustration, adding visual interest, while the drop shadow lifts the entire image off the page. The stippling technique was used to render the sand texture. Stencils were used for the rectangular shapes and the turtle.
*Artist: Ed White*

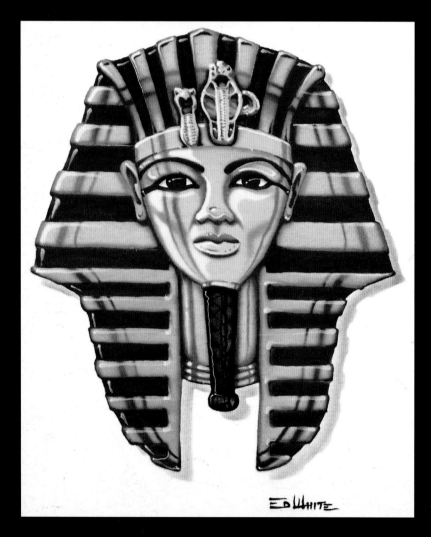

Customers can be found everywhere, and this Egyptian head appeals to college fraternities, which buy airbrushed T-shirts in bulk. The intricacy of this illustration required the use of many small stencil pieces that the artist fit together like a puzzle, making this stencil design more time-intensive than most. Notice how the metallic effect is achieved through the use of gold color, bright highlights and minimal shading.
*Artist: Ed White*

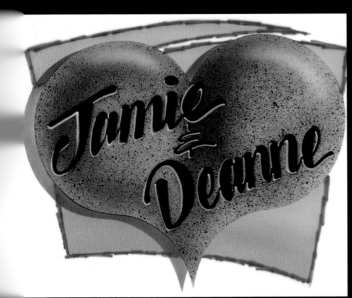

This standard romantic design features bright colors and an unusual stone-quality heart. To create the stone, the artist sprayed a base gray tone through an outline stencil, then stippled black and teal over the base tone. A second stencil was used to create the translucent blue drop shadow. Notice the ragged line quality freehanded around the pink background, which adds textural contrast to this crisp-edged piece.
*Artist: Joan Sanders*
© Joan Sanders and Rich Champagne, Airresistible.

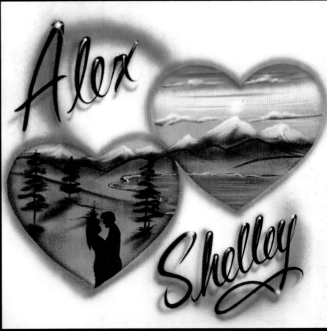

Double hearts is a popular format everywhere. Here it is handled uniquely by depicting two lovers and a mountain scene background. The artist used stencils to render the hearts and the two figures. The lettering is rendered in script, and a soft-edged oval unifies all of the elements.
*Artist: Rick "Rix" Kordsmeier*
© Rick Kordsmeier

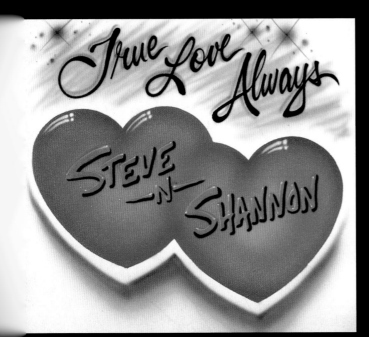

For this couples design, the artist used a stencil to render the double-heart interior; the remainder of the illustration was freehanded. The color palette, particularly the aqua lettering, makes the illustration stand out.
*Artist: Steve Burrows*

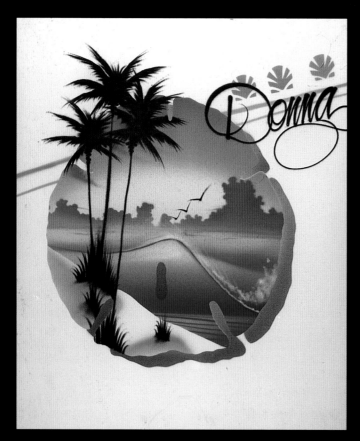

This sunset-in-a-sand-dollar design has been popular in Florida tourist areas for over fifteen years. Two stencils are used, one for the sand dollar shape and the other for portions of clouds; these same two stencils can produce over 200 illustrated shirts before the artist needs to cut new ones. The coloration of the sunset, which is standard to the artist's color palette, depicts the colors of the rainbow, starting at the top of the illustration with blue, progressing to yellow, then orange and pink. Slight overspray of blue and yellow adds a green tone.

*Artist: Don Ashwood*

This sunset and name design is a classic design for this Florida artist. Its simplicity makes it very adaptable to other locations, such as a lakefront, by changing the palm tree to cattails. It can also adapt to the addition of two names. The coloring is kept vivid, such as with the magenta clouds, because as this successful artist has learned, color sells. A paint jar lid was used as a stencil to create the sun shape.

*Artist: Terry Hill*

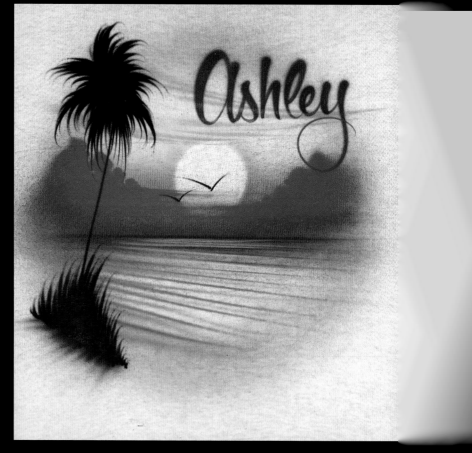

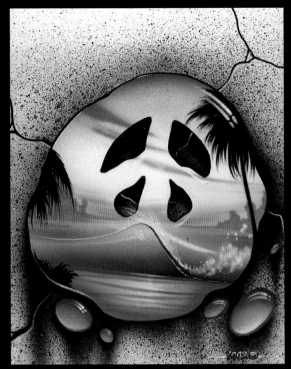

The granite background, a prominent feature of this design, was stippled, and the black peace sign shapes sprayed, after the water drop shape was covered. The artist used a unique and effective method of stippling. Instead of lowering the psi (pounds per square inch of air pressure) as most illustrators do, he maintained his normal 60 psi, but sprayed the paint at a forty-five degree angle onto a clothespin held close to the fabric. The paint flickered off the clothespin to create large stipples that you could not produce with the low psi method.
*Artist: Don Ashwood*
© Don Ashwood. All Rights Reserved.

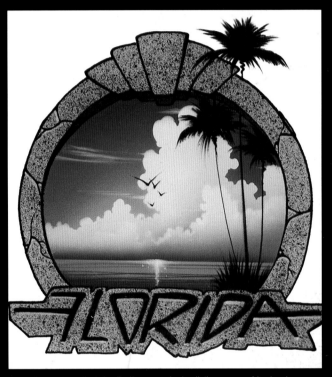

Affectionately called the "toilet seat design" (because of its basic shape), this image is very popular with the customer who already owns a few standard beach scene T-shirts and who now wants a more sophisticated design. In the stenciled clouds, note the use of warm pink coloring rather than the typical cool blue.
*Artist: Don Ashwood*
© Don Ashwood. All Rights Reserved.

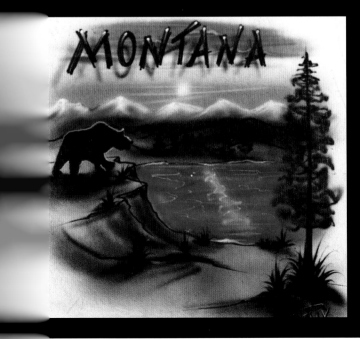

Sunset scenes aren't only the domain of Florida T-shirt artists. This Montana artist features sunsets in his nature, romance and lettering images. Notice the drop shadow that sets the lettering off from the illustration. A stencil was used only for the bear shape. This image is one of the artist's best sellers in Kalispell, Montana.
*Artist: Rick "Rix" Kordsmeier*
© Rick Kordsmeier

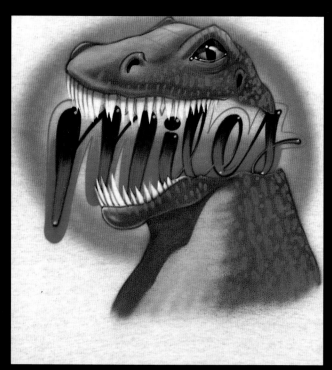

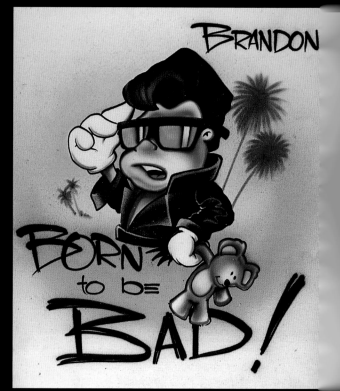

Children are the usual customers for dinosaur illustrations. The color combinations and lettering location make the composition unique. Two stencils were used for the lettering. The dinosaur was first under-painted in purple with opaque blue scales layered on top. The entire dinosaur was then sprayed with fluorescent green.

*Artist: Rich Champagne*

© Rich Champagne

Although the artist created this original cartoon figure for kids, it is just as popular with adults. Two stencils are used; one covers up the figure while the background and lettering are sprayed, and the other covers up the background while the hair, jacket, bear and sunglasses are painted.

*Artist: Don Ashwood*

© Don Ashwood. All Rights Reserved.

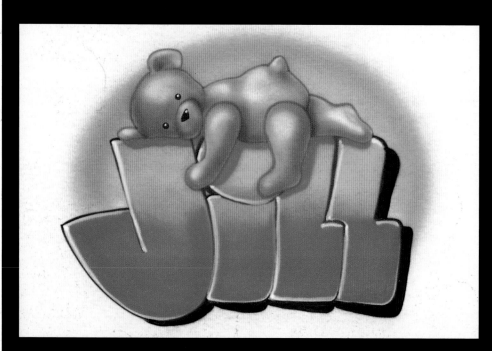

Little girls love this design because of its bright colors and the ever-popular teddy bear, which the artist incorporates with the lettering. The relationship between these two elements makes this a unique name-design composition. Notice how the pink background unifies the composition. A stencil was used to protect the bear while the lettering and background were sprayed.

*Artist: Joan Sanders*

© Joan Sanders and Rich Champagne, Airresistible.

This design exemplifies one reason why airbrushed T-shirts are popular: It commemorates the year and location of the customer's vacation. The artist made this traditional concept more sophisticated and visually exciting by combining bright, vibrant colors with a granite background. One stencil was used for the exterior shapes and the granite texture; colors were chosen for these areas so they would recede within the overall design. A second stencil was used for the lettering *'93.*
*Artist: Steve Burrows*

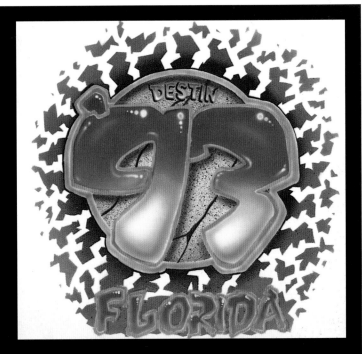

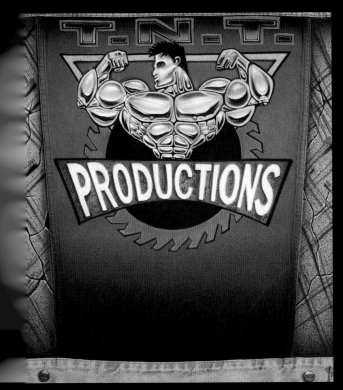

This illustration was painted on a light-blue denim jacket for the producer of bodybuilding shows. The artist, who is well known for his ability to render metallic surfaces, has studied extensively the work of Japanese artist Hajime Sorayama, who paints the popular sexy robots. The trick for rendering believable metallic surfaces, as shown here, is the addition of color reflected from surrounding objects. The red and black background paint streaks were added by removing the dip tube from a paint jar and throwing the paint onto the design (after covering up the interior image area).
*Artist: Terry Hill*

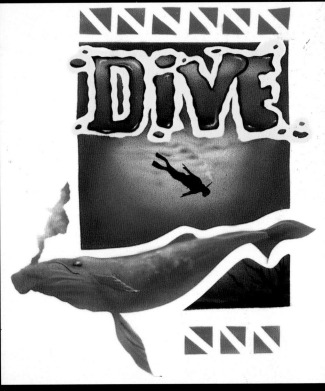

This standard design is very popular in the Panama City Beach, Florida, area because of the strong interest in water sports among tourists and residents. The unique lettering style suits the aquatic theme and the bold yellow outline gives it appropriate vibrance and dominance. Mylar stencil material was used for this complex design.
*Artist: Rich Hernandez*

# How to Airbrush Freehand

## CHAPTER

Airbrushing freehand offers the greatest creative freedom—and also requires the greatest amount of skill. You must be able to anticipate the results of each hand movement you make. Mastering your airbrush will allow you to render custom illustrations that are challenging, fun and profitable.

Freehand spraying coupled with good drawing skills creates an unbeatable combination; however, until your drawing skills become strong you can transfer sketches onto your surface using one of the techniques described in chapter one (see pages 5-6).

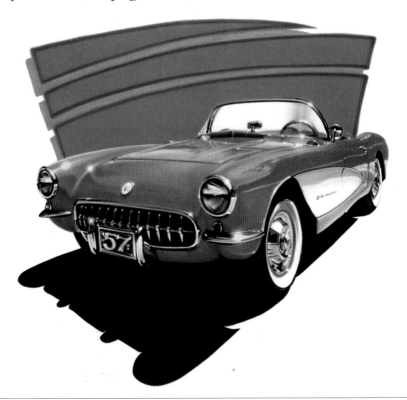

# RENDERING BLOCK LETTERING

**Materials:** T-shirt or practice fabric; vine charcoal

**Acrylic Fabric Paint:** Black and magenta

**TECHNICAL NOTE:** Vine charcoal is a good medium for drawing directly onto your fabric because it can give you a range of line weights. In addition, you can erase a lightly drawn vine charcoal line from fabric by spraying air only from your airbrush directly at the misdrawn line.

While completing the freehand projects in this chapter, it is important to concentrate on controlling the airbrush, since you will not have a stencil to protect surrounding areas. Remember, the closer the airbrush is to the fabric, the finer the spray and the resulting line. The farther you move it from the fabric, the broader the paint cover becomes.

**Step One**

Using vine charcoal, lightly sketch a block-style *E* (or a letter of your choice) on your fabric.

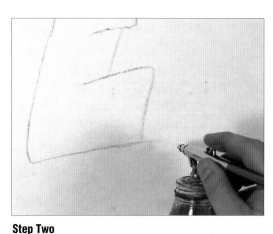

**Step Two**

If you goof, such as extending a charcoal line too far, "erase" the misdrawn line using your airbrush. To do this, hold the airbrush 1/8 to 1/4 inch from the surface and push down on the trigger so you release only air. Do not pull the trigger back, or you will release paint also.

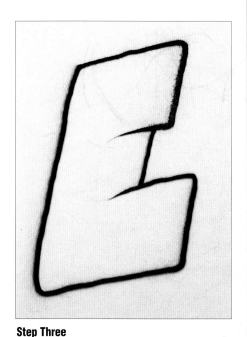

**Step Three**

Spray a fine black line over the charcoal line by holding the brush 1/4 to 1/2 inch from the surface.

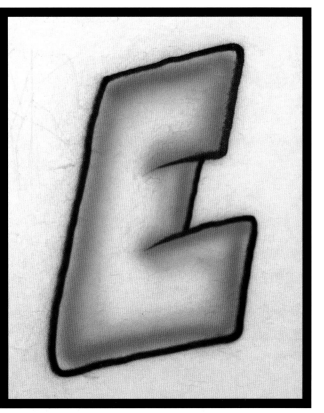

**Step Four**

Add magenta, or any color, as desired. You can simply outline the letter, or you can fill it completely with color. Heat-set the illustration if it is to be worn and washed. See page 17 about heat-setting.

# FREEHANDING SCRIPT LETTERING

**Materials:** T-shirt or practice fabric
**Acrylic Fabric Paint:** Black, light blue and white

TECHNICAL NOTE: To avoid wasting good-quality fabric, practice spraying script letters on newspaper or uncoated cardboard until you like the results and feel comfortable enough to spray on fabric.

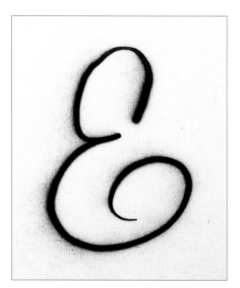

**Step One**
Holding the airbrush about 1/4 inch from the surface, draw the script *E*. To add visual interest, vary the line width by pulling the trigger farther back.

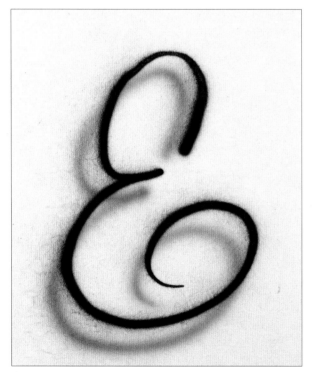

**Step Two**
Add a blue drop shadow, using the step one spraying technique.

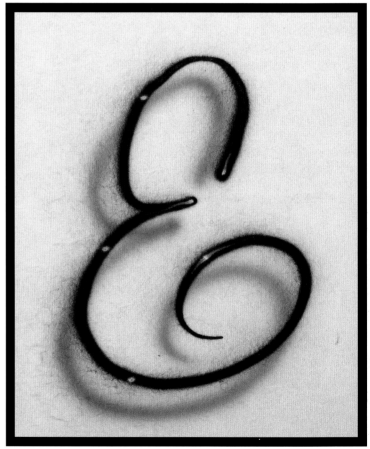

**Step Three**
Add white highlight dots, which give sparkle to script lettering. Heat-set the illustration.

# FREEHANDING SPIKE LETTERING

**Materials:** T-shirt or practice fabric; vine charcoal

**Acrylic Fabric Paint:** Black

**TECHNICAL NOTE:** Spike lettering requires that you use the taper stroke, which combines thick and thin line qualities. Read page 14 for guidelines on airbrushing the taper stroke.

To render the drop shadow, use the same taper stroke as you do for the word *ROCK* in step two. The only difference is that you should not pull the trigger back as far so the resulting spray is softer. Do not use gray for the drop shadow, because the white paint that is used to mix gray is opaque and will cover the black lettering you painted in step two. A soft spray of black will produce a believable gray tone.

**Step One**
Sketch the letters on your fabric using vine charcoal.

**Step Two**
Using long taper strokes, spray the letters black.

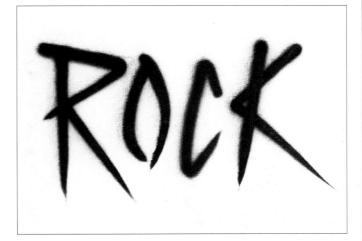

**Step Three**
Add the drop shadow by repeating step two and applying only a light coat of black to the lower left area of the letters. The resulting tone should look medium gray. Use the blow-out technique described on page 73 to remove any remaining charcoal from the original sketch. Heat-set the illustration.

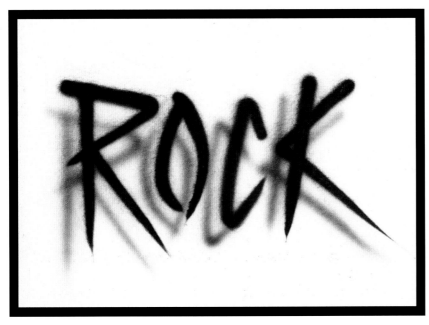

# RENDERING A COMPLETE SCRIPT NAME

**Materials:** T-shirt or practice fabric; vine charcoal

**Acrylic Fabric Paint:** Black, magenta, yellow, blue and white

**TECHNICAL NOTE:** Lettering guidelines drawn lightly with vine charcoal will help you sketch a steady script name. Remember, though, to blow out the guidelines before you spray any paint other than black over them, since the paint will seal the charcoal in the fabric. If the paint you sprayed is light colored, the charcoal will show through it.

Vary the thickness of the airbrushed line quality as you did in the second project in this chapter. To aid in airbrushing a steady line, support the bottom of the paint jar with your free hand.

**Step One**

Using vine charcoal, lightly sketch the lettering. Don't worry if your lettering is flawed; you can use the blow-out technique described on page 73 to remove misdrawn charcoal lines.

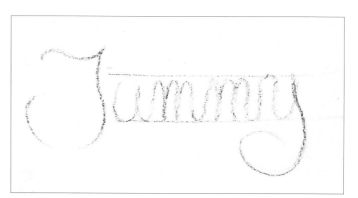

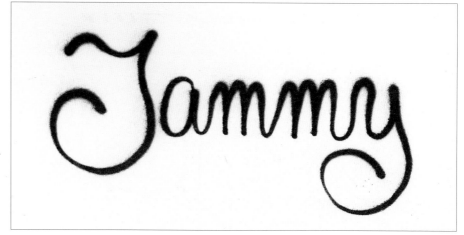

**Step Two**

Airbrush the lettering with black; to spray a thin line, hold the airbrush close to the shirt and pull the trigger back one-half of its moving distance. Blow out the charcoal guidelines.

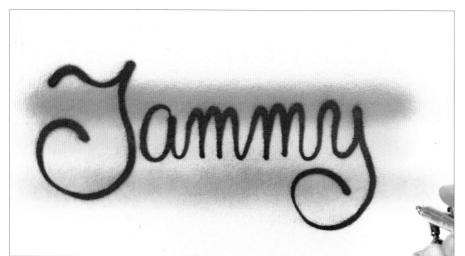

**Step Three**

To decorate the name, spray different bands of color across it. You can spray directly over the black because the color you are spraying is transparent. Hold the airbrush 6 to 7 inches from the shirt to create soft, wide bands. Control the bands' color intensity by how far back you pull the trigger. Allow the bands to overlap and blend to create more colors.

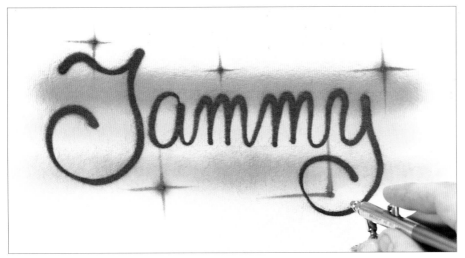

**Step Four**

Add colored starbursts using the technique described on page 16.

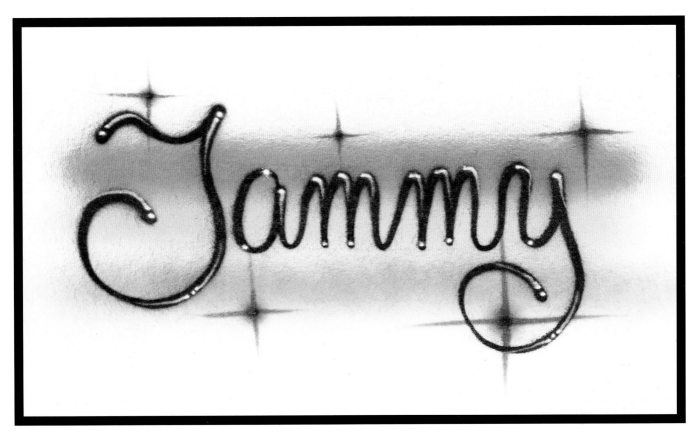

**Step Five**

Add white highlights using the technique described on pages 7 and 11-15. Use the blow-out technique described on page 73 to erase any remaining charcoal lines. Heat-set the illustration.

# COMBINING SCRIPT, BRUSH AND BLOCK LETTERING

**Materials:** T-shirt or practice fabric; vine charcoal

**Acrylic Fabric Paint:** Black, orange and white

TECHNICAL NOTE: Notice as you progress through this project how the line quality varies among the three lettering styles. Step two describes the specific techniques that, ultimately, you should master.

**Step One**

Using vine charcoal, sketch the design on your fabric.

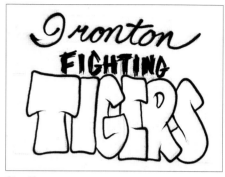

**Step Two**

Go over the lettering styles with black. Outline *IRONTON* holding the brush 1/4- to 1/2-inch from the fabric and changing the trigger position to vary the line thickness. To spray *FIGHTING*, use a scribble motion, rocking the trigger back and forth slightly to vary the line thickness. For *TIGERS*, simply outline the letters evenly, ending each stroke with a taper.

**Step Three**

Fill in the word *TIGERS* by first outlining the letters with orange using the same technique as in step two.

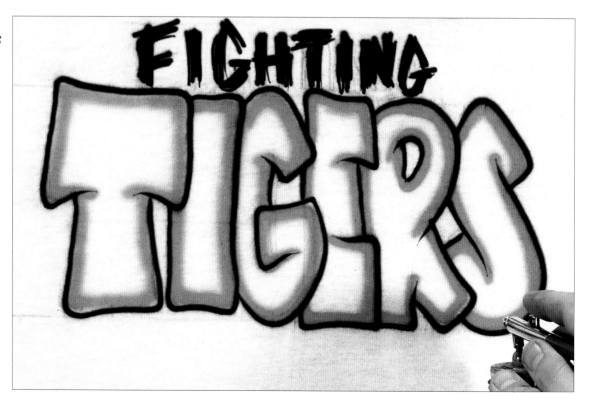

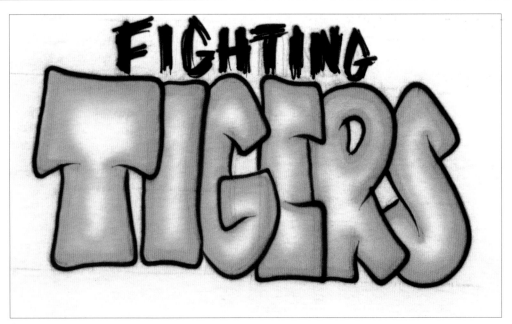

**Step Four**
Gradate a lighter application of orange toward the center of each letter.

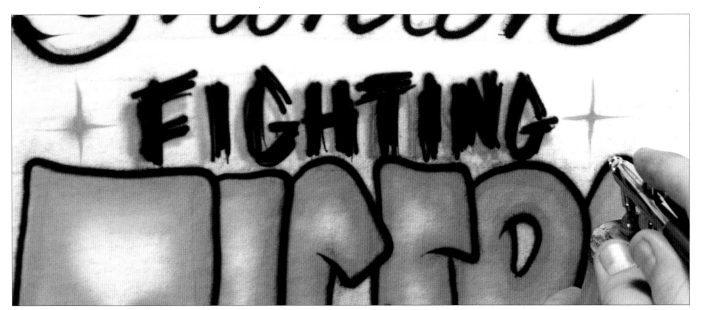

**Step Five**
Decorate the word *FIGHTING* by spraying orange to the left side and bottom of each letter. Do not worry about spraying over the black lettering. Add a starburst to each side of the word.

**Step Six**

Decorate *IRONTON* by spraying a band of orange through the word. The orange color will appear to be behind the lettering.

**Step Seven**

Add a drop shadow to the words *IRONTON* and *TIGERS* by holding the brush ½ inch from the fabric to create a thin spray of black and pulling the trigger back one-quarter of its moving distance to create a gray tone.

**Step Eight**

Add black accent lines to the orange *TIGERS* on the shadow side.

**Step Nine**

Add white highlights to the black lettering.

**Step Ten**

Add the white highlights opposite the shaded side of *TIGERS* to create a three-dimensional look.

Blow out any excess charcoal. Heat-set the illustration.

# AIRBRUSHING AN ILLUSTRATION ON CANVAS

**Materials:** Primed canvas; vine charcoal
**Acrylic Fabric Paint:** Black, light blue and white

**TECHNICAL NOTE:** Paint reacts differently to a canvas surface, depending upon whether it is primed or unprimed. This project uses canvas that was purchased primed and pre-stretched (that is, mounted on a frame) from an art supply store. Spraying on primed canvas is much like working on leather (except for the color difference), so before you start this project read pages 16-17 for more information about spraying on canvas and on leather.

**Step One**

Using vine charcoal, sketch the design on the canvas. Outline the drawing with black.

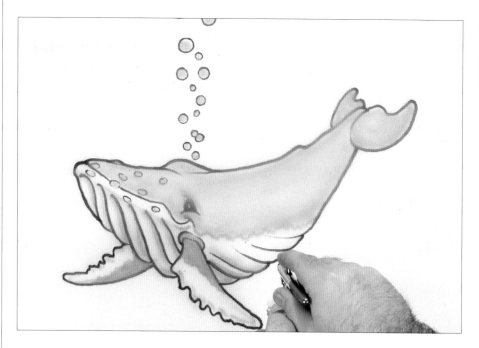

**Step Two**

Fill in the whale's upper body and the water bubbles with light blue. Spray in a mist of lines to create shading on the underside of the whale.

**Step Three**

Add accents to the bubbles with heavier concentrations of light blue.

**Step Four**

Add shading to the whale by applying heavier coats of light blue.

**Step Five**

Add accents and contour lines using light blue in the same manner you used to create the black outline in step one.

**Step Six**

Darken the eye with black.

**Step Seven**

Add white highlights to the bubbles and the whale.

**Step Eight**

If the illustration is to be washed, heat-set it first. If the illustration is to be a decoration, simply
frame it and hang it.

# COMBINING MULTIPLE LETTERING STYLES AND ILLUSTRATION

**Materials:** T-shirt or practice fabric; vine charcoal

**Acrylic Fabric Paint:** Black, orange, turquoise, white and red

TECHNICAL NOTE: The technical feature of this illustration is contrast, which you can see in the color palette and in the way lines are used. The complementary hues of orange and turquoise produce a much stronger contrast than could have been achieved using low-value analogous colors, such as yellow and orange. Contrast is also achieved through the variation in line widths of the taper strokes, adding visual interest to the image.

**Step One**

Using vine charcoal, sketch the design on your fabric.

**Step Two**

Outline the entire sketch with black, maintaining a thin stroke on interior lines and a thicker stroke on outer edges. Fill in the tires with solid black.

**Step Three**

Shade the drawing with light coats of black to create a gray tone. Darken the windows and spoiler with solid black and add the black shadow beneath the truck.

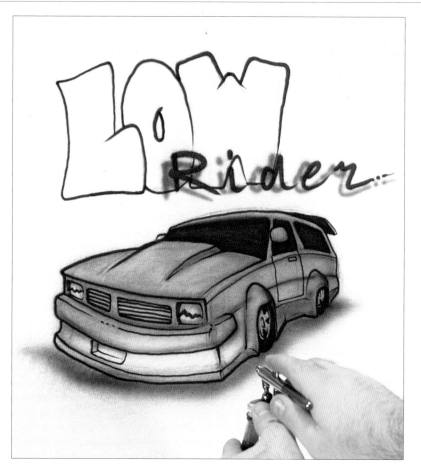

### Step Four

Add color by first applying a light coat of turquoise. Airbrush the drop shadow to the word *RIDER* by duplicating each letter to the bottom left of the original lettering.

### Step Five

Add shading with coats of turquoise in shadow areas. Also, use the taper stroke to add blue reflection lines to define the shiny finish.

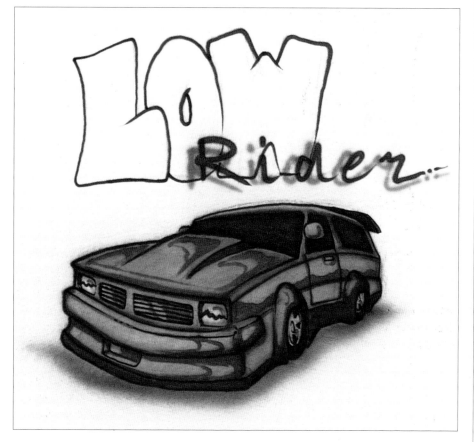

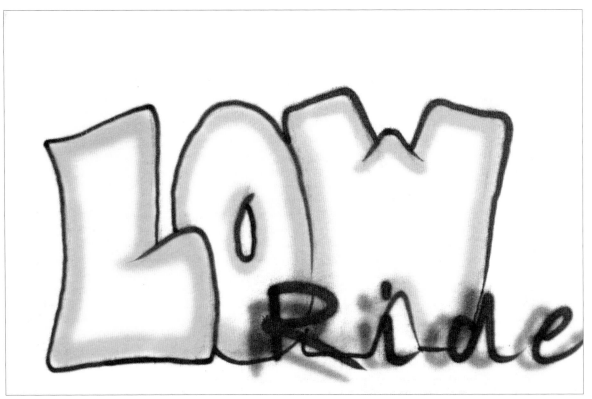

**Step Six**

Outline the word *LOW* with orange in the same way you did the word *TIGERS* in the project on pages 41-45.

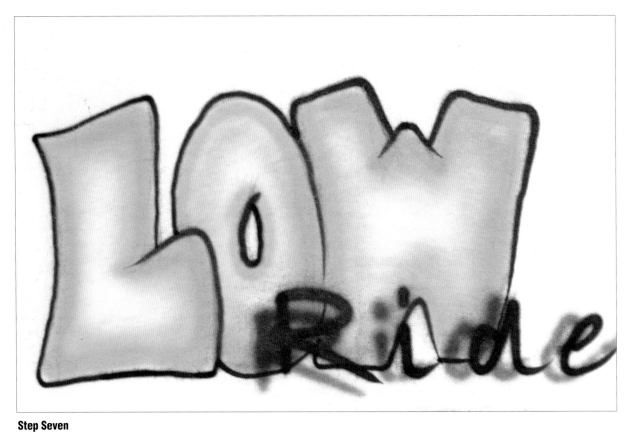

**Step Seven**

Gradate orange toward the center of each letter.

**Step Eight**

Go over the orange with red.

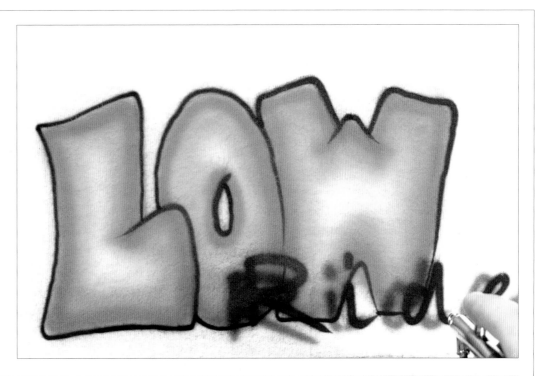

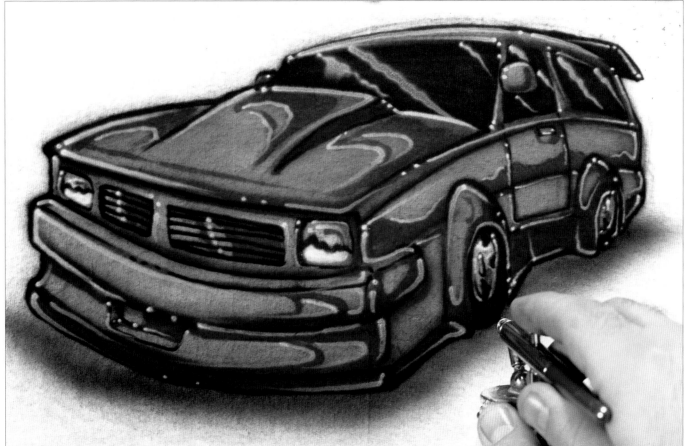

**Step Nine**

Add white highlights to the truck to create a shiny-looking finish.

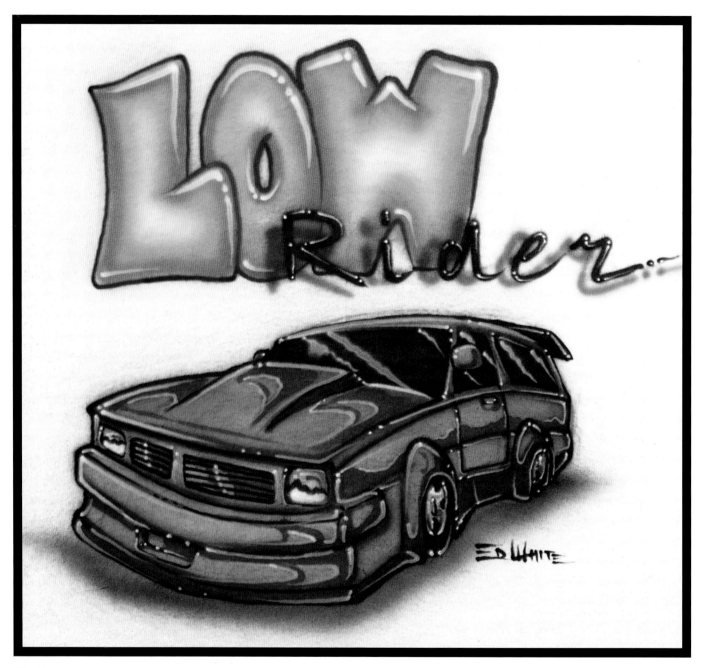

**Step Ten**

Add white highlights to the letters to give them dimension. Blow out the excess charcoal and heat-set the illustration.

# AIRBRUSHING ON BLACK FABRIC

**Materials:** Black T-shirt or practice fabric; stencil burner
**Acrylic Fabric Paint:** White, magenta, yellow, orange and black

**TECHNICAL NOTE:** This project introduces a number of new techniques. Before beginning, you should read about airbrushing on dark fabric (page 18), using the pounce transfer technique (see page 5), using a stencil burner (see page 28) and copyright legalities (see page 4).

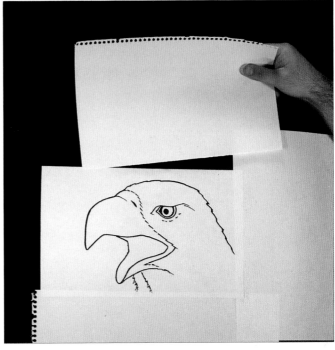

**Step Two**
Lightly spray the back of the pouncing stencil with adhesive spray mount, then position it on your fabric. If the stencil is not large enough to cover the entire shirt, protect the fabric surrounding the stencil with scrap paper, which you can spray lightly with adhesive spray mount and stick on the shirt.

**Step One**
Photocopy an image of an eagle out of a magazine or a book. (One caution: Copyright law prohibits reproducing and selling a copy of someone else's illustration or photograph.) Use one of the sketch transfer techniques on pages 5-6 to create a line drawing of the image. Lay the drawing on a piece of cardboard and, using a stencil burner, an ice pick or other sharp, pointed tool, burn or pierce small 1/8-inch holes at 1/2-inch intervals along the line drawing to create a pouncing stencil.

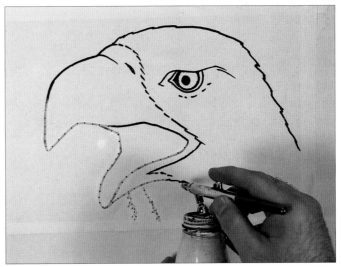

**Step Three**
Spray white along the pounced lines. The goal is for the paint to go through the holes and create a light, dotted outline on the fabric.

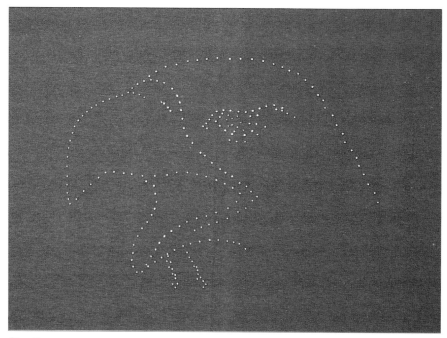

**Step Four**

Remove the pouncing stencil. Your drawing is outlined on the fabric with white dots.

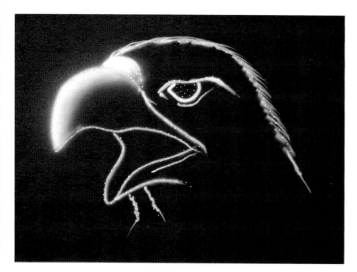

**Step Five**

Connect the dots by holding the brush 1/4 to 1/2 inch from the surface and spraying white paint. Add white shading to the top of the beak. This shading, and the shading you will add in the next step, is important because it creates a white base coat or foundation upon which to spray color. If your white shading gets too heavy and feels wet, you should stop work and heat-set the color (see page 17). If you do not do this, color that you add on top of the white will mix with the white and will lose its intensity.

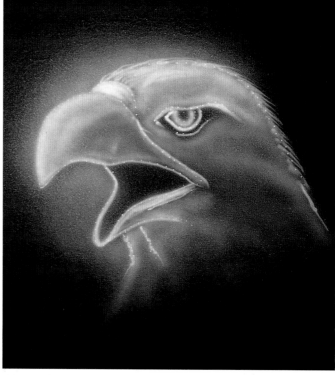

**Step Six**

Continue shading the eagle with white. Spray white shading about the eagle's face and beak, where you will next add background color.

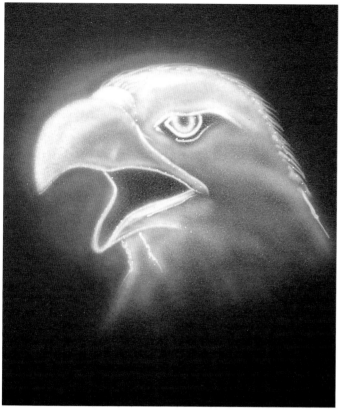

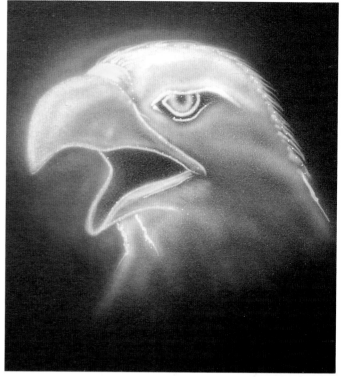

**Step Seven**

Spray light coats of magenta over the white background, until you reach a medium intensity.

**Step Eight**

Spray light coats of yellow on the beak and eyes, building the color as you did in the previous step.

**Step Nine**

Spray orange on the beak and eyes to define them.

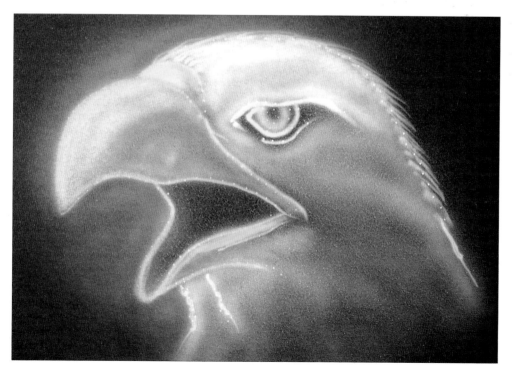

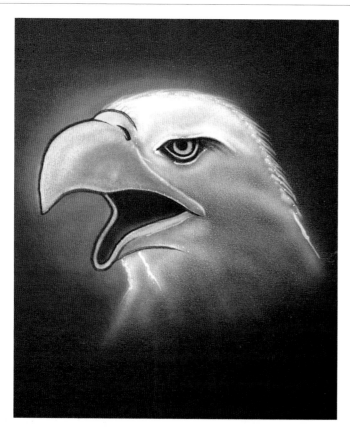

**Step Ten**

Spray black over the head and neck to add dark shading and form. If you happen to apply too much black, tone it down by overspraying with white. Outline the beak and darken the eyes with black.

**Step Eleven**

Add feather texture around the beak, neck and eye by spraying black taper strokes.

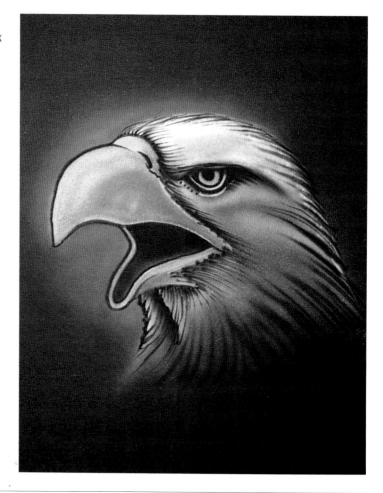

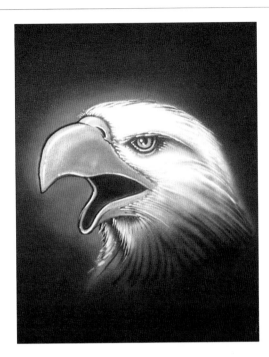

**Step Twelve**
Holding the brush about ¼ inch from the surface, spray white taper strokes around the beak, neck and eye, and add white highlights to the eye.

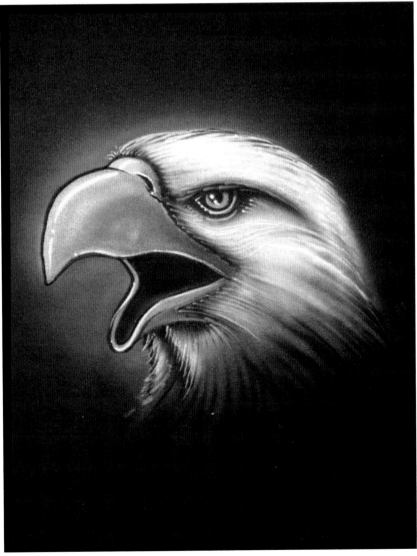

**Step Thirteen**
Continue refining with more black shading. Heat-set the illustration.

# PROFESSIONAL PORTFOLIO

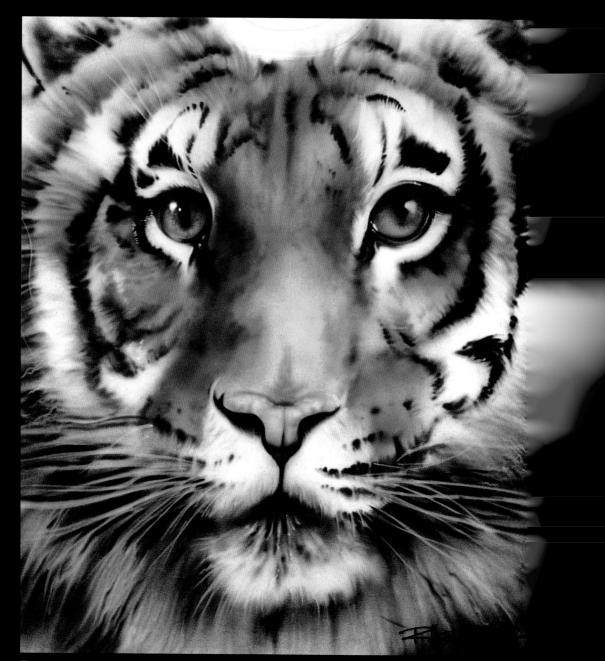

This custom image superbly demonstrates many of the elements that go into a photorealistic illustration. The application of color shows many subtle tonal changes and gradations; for example, the subtle gradation in the eyes makes them very realistic. The blending of taper and squiggle strokes and differing line thicknesses creates a collage of textures. Fine detailing is added by the random spots of black and brown in the fur and the almost imperceptible, but authentic, shading in the nose. Finally, the direct perspective adds drama to this dynamic illustration.

*Artist: Rich Hernandez*

The colors of this classic skull image were developed following the sequence used in the four-color printing process: Yellow, magenta, blue and black were applied, highlights were added, and the resulting image was softened with a light application of white. The drop shadow accentuates the skull's form.
*Artist: Ed White*

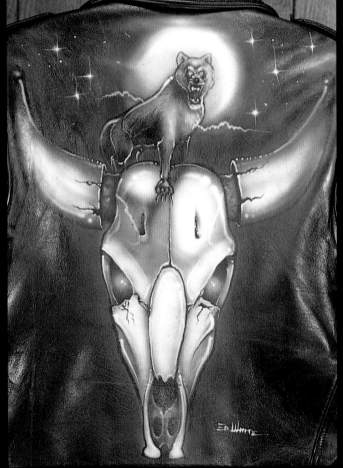

This image shows how a subject can be airbrushed in very different styles for contrasting effects. Compare the skull image above to this one, which was rendered on black leather for a more dramatic effect. The addition of glowing eyes adds a key focal point and dramatic element.
*Artist: Ed White*

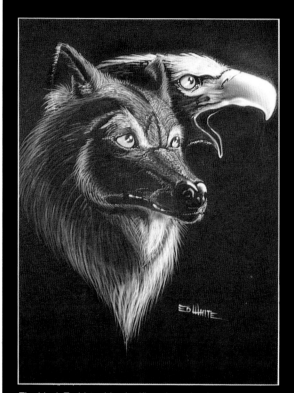

The black T-shirt adds significantly to the dark mood of
this unusual portrait. Unity is achieved through the juxta-
position of the wolf and the eagle and the similar render-
ing of fur and feathers and eyes.
*Artist: Ed White*

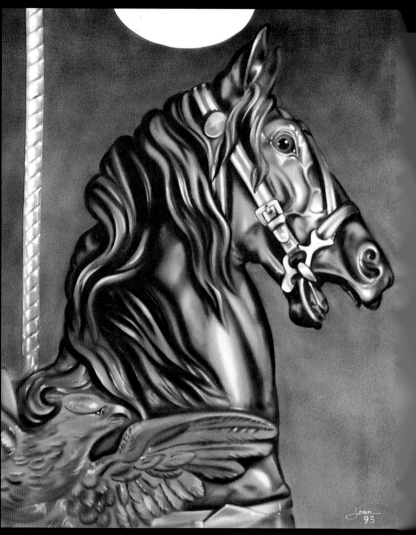

The motivation for this custom illustration was the artist's affinity for carousel horses,
which she feels are more realistic-looking than most illustrators depict. Rather than fol-
low suit and airbrush a "nice and cute" horse, the artist painted what she saw: A sur-
prised and scared horse with fierce eyes. She achieved the realism of the carved surface
by layering strokes and blending the resulting lines and shapes using dark shading. The
highlights of the mildly reflective surface are not super-bright, and so they are painted
mostly with gray; white is used only on the very brightest areas.
*Artist: Joan Sanders*
© Joan Sanders and Rich Champagne, Airresistible.

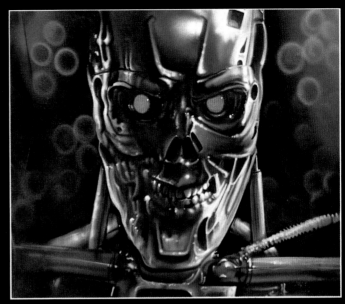

The evilness of the ever-menacing Terminator character is rendered using a cool, dark color palette, dominated by blues and black. Painted on a black T-shirt, which adds drama, the illustration builds its metallic effect by featuring intricate and extreme shading, highlighting and gradation. In contrast, the hot red eyes become the immediate and riveting center of focus. Notice the addition of the highlight specks that give the eyes a glint, but retain their inhuman flatness.
*Artist: Rich Hernandez*

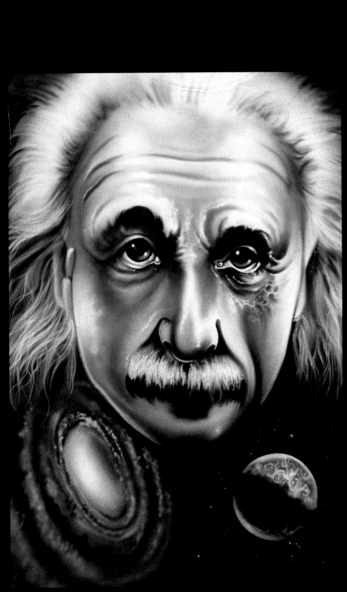

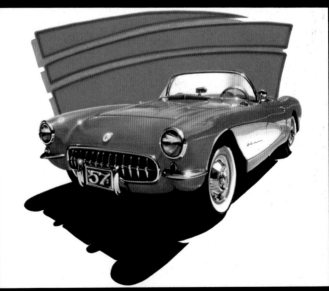

Titled "World Thought," this custom illustration uses extreme contrast—dark darks and bright highlights—to build the strong form and texture in Einstein's face. The edge quality of these tones is kept soft, resulting in a gentle facial quality. Taper strokes were used to produce the hair texture, the dominance of cool blues creates the sense of outer space, and very light stippling of stars behind the planet adds a sense of great distance.
*Artist: Rich Hernandez*

The graphic background helps set this car off from the shirt, with a contrasting color and simple shapes making the car even more significant. The underpainting of the car was brown, with transparent red layered over it.
*Artist: Rich Champagne*
© Rich Champagne

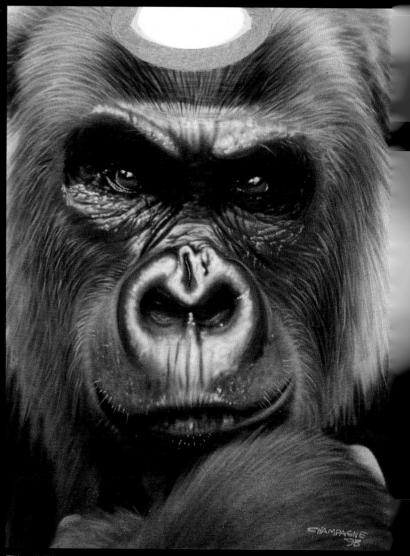

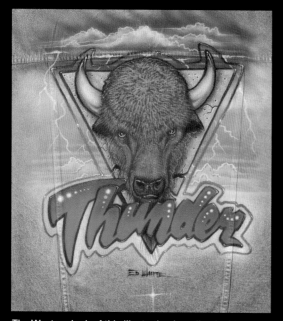

The Western look of this illustration is well-suited to a denim jacket. The textured triangle helps to set off the buffalo's head from the jacket. The bright colors of the sunset in the background create an interesting contrast with the darker colors of the jacket and the buffalo's head.
*Artist: Ed White*

This wildlife portrait, a subject that is very popular with the young and the environmentally conscious customers, offers a different interpretation from the one by Terry Hill on page 104. (Notice, though, that the basic color palette is the same for both illustrations.) For this piece, the artist worked from a photograph, modifying the gorilla's hand and raising one of its eyebrows to make it appear as if the gorilla is studying the world from the T-shirt. The illustration used six colors: black, blue, purple, yellow, red and white. The hair was created by rendering dozens of small, white lines of varying intensity and crispness. The skin wrinkles resulted from layering black, blue, purple and white.
*Artist: Rich Champagne*
© Rich Champagne

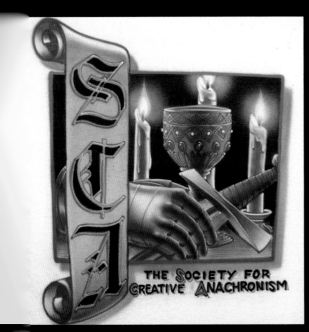

The most distinctive technical feature of this illustration is the lighting. The artist wanted to render a dark, candlelit room, which meant that highlights and counterlights had to be strong. To paint the image, he imagined two light sources, one yellow and one blue, positioned directly opposite one another.
*Artist: Rich Champagne*
© Rich Champagne

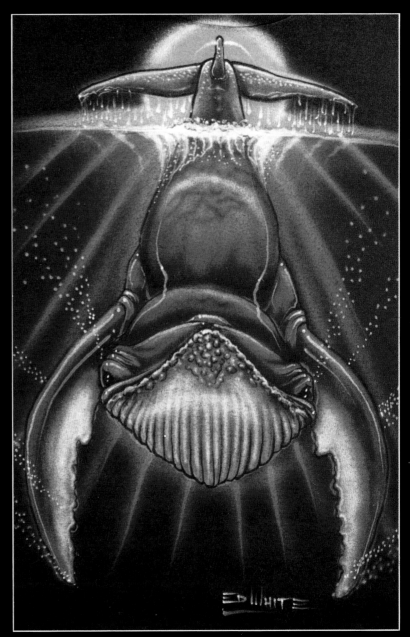

The impact of this illustration comes from its unique perspective, the use of a black T-shirt and the focus on a single, large subject. To create a sense of movement the artist used dots and taper strokes.
*Artist: Ed White*

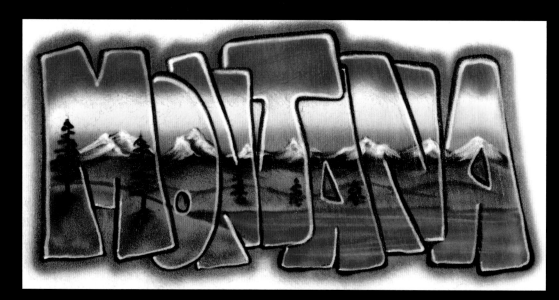

Entirely fre
this block l
demonstra
cial way to
lettering ar
scape scen
tering was
first, follow
interior ima
soft outline
white highl
added last.
*Artist: Rick*
*Kordsmeie*
© Rick Kordsr

Sometimes, the most
effective way to ren-
der lettering isn't to
use special tech-
niques, but to drama-
tize the letter shapes.
In this block lettering
the shapes were dec-
orated using basic
techniques of outlin-
ing, gradation and
highlighting.
*Artist: Rick "Rix"*
*Kordsmeier*
© Rick Kordsmeier

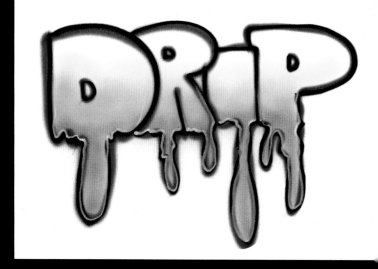

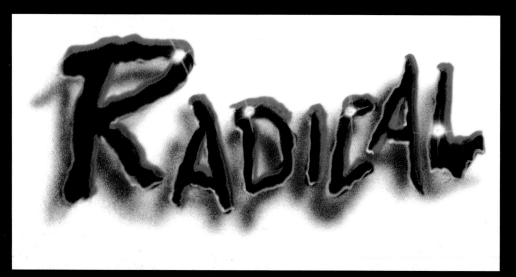

An artist's imagination
can be a terrific source
of inspiration. Entirely
freehanded, the style is
produced simply by
moving the airbrush
while spraying. Double
drop shadows, in dif-
ferent colors, add inter
est, and highlights are
minimized.
*Artist: Rick "Rix"*
*Kordsmeier*
© Rick Kordsmeier

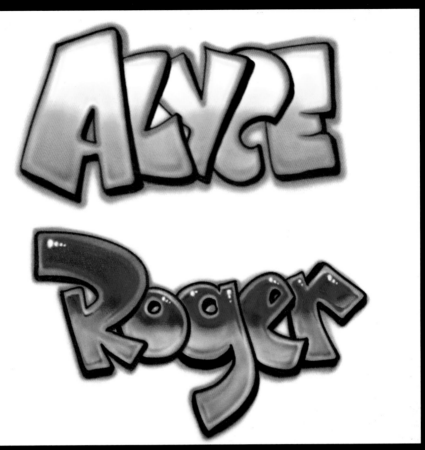

These renderings show two popular name styles and color schemes. The technique for rendering them relied heavily on outlining in black and in multiple colors. Highlighting is minimal.
*Artist: Steve Burrows*

ultiple styles, as shown here. Classic lettering is combined with the word , yellow-brown color scheme to create a Western look.
smeier

The ultra-photorealism of this illustration is amazing. As with the other highly realistic illustrations in this book, it pushes techniques and effects as far as possible. Notice that the sleepiness of the eye is achieved using blue and black, and only the hint of a highlight. The highlights include large areas of white and small masses of individually sprayed dots, blended slightly by overspray. A yellow mist added after all other colors were laid down produced a quality of sunlight that pure white highlights couldn't have done.
*Artist: Joan Sanders*
© Joan Sanders and Rich Champagne, Airresistible.

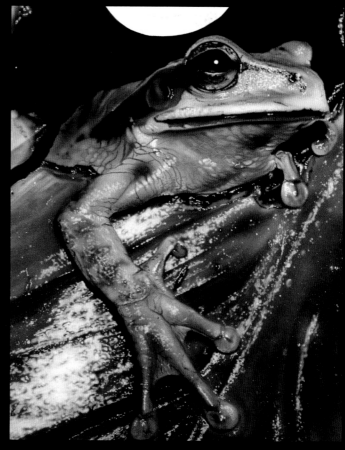

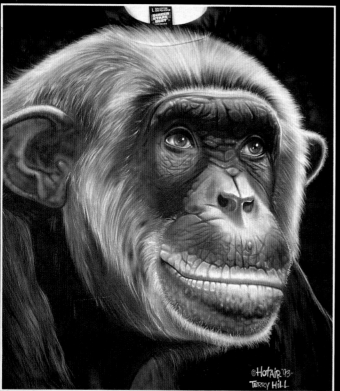

This custom shirt was inspired by an article in an in-flight magazine, which featured a photo of an old, wise-looking chimpanzee. The first element sprayed was the chimp's left ear, which let the artist experiment with colors before completing the illustration. To achieve the translucency of the ear skin, a final application of fluorescent pink was sprayed. For the head, an underpainting of black, brown, purples and small amounts of red and blue were sprayed so these colors would show through and give more emphasis to the white fur texture. The fur texture was then toned down with light applications of brown, blue and gray. Notice the extensive use of the taper stroke to render the complex facial texture and the fur.
*Artist: Terry Hill*
© 1993 Terry Hill, Hot Air. All Rights Reserved.

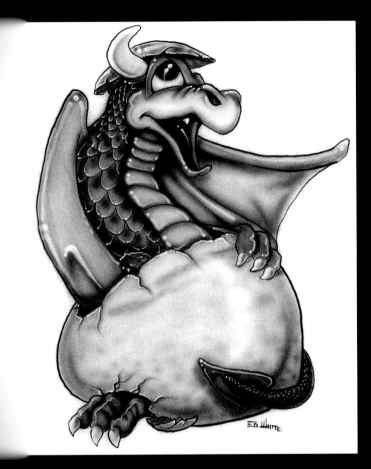

This cartoon image was given a stronger than usual sense of realism through the extensive development of shading. The texture of the scales was created by gradating them in size, after which the artist shaded them individually.
*Artist: Ed White*

The circular format makes this graphically styled river scene unusual. The artist used the popular technique of framing the image area with dark foliage and cattails.
*Artist: Ed White*

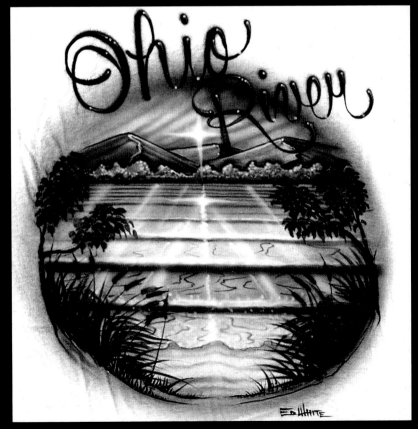

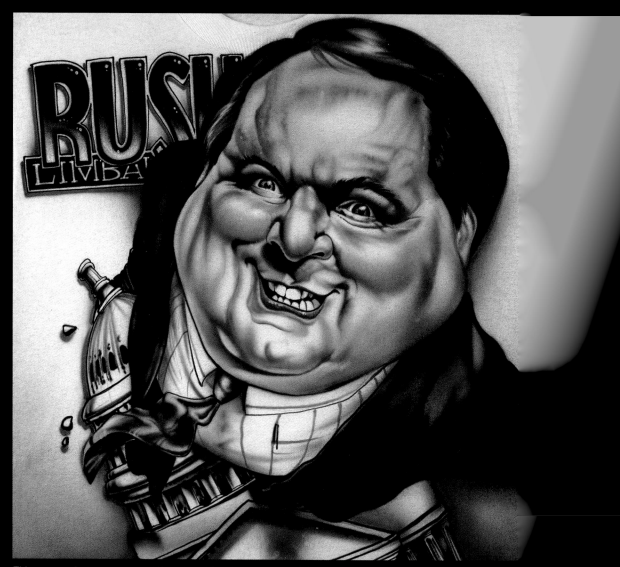

This custom design was created for a fan of the ultra-conservative TV and radio host Rush Limbaugh. Entirely freehand, and rendered in only black and white, the illustration features a caricature style. Compositionally, the face was sprayed first, using a picture of the subject as reference; then the artist added the background Congressional building (representative of a popular Limbaugh target). The lettering was added to guarantee recognition of the subject.

*Artist: Don Ashwood*

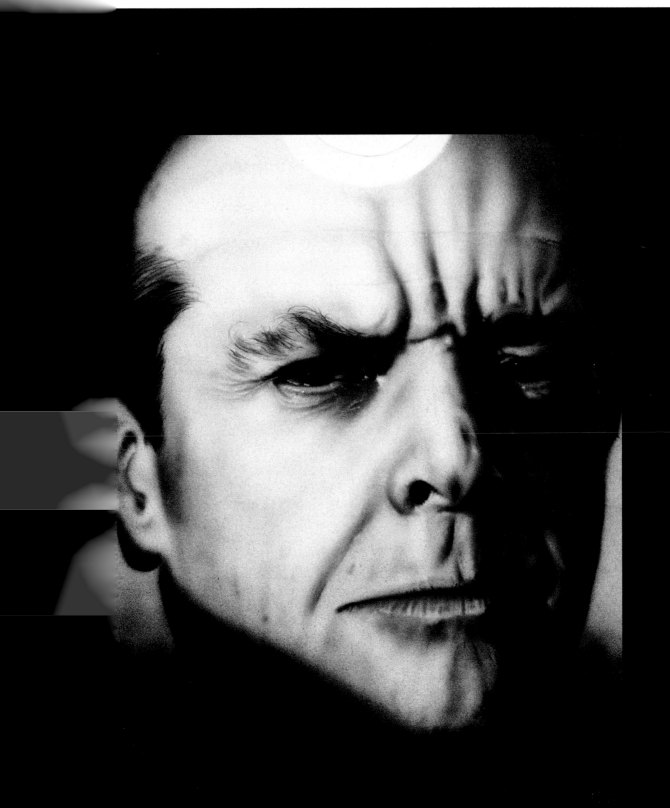

This rather uncomfortable feeling of being up close and personal with Jack Nicholson results from an ultra-tight, three-quarters view perspective, a very well-defined and furrowed brow, and intense, piercing eyes. The somber, photorealistic portrait was built on only three colors: black, white and gray.
*Artist: Joan Sanders*
© Joan Sanders and Rich Champagne, Airresistible.

# Illustration Templates

## CHAPTER

This chapter reproduces the line drawings you need in order to recreate the projects in chapter three. To transfer these drawings to your stencil material see pages 5-6 for sketch transfer techniques. You can also use these drawings, if you prefer, to airbrush them freehand. See page 6 for techniques for transferring the drawings directly to your fabric.

Before you cut your first stencil, read stencil chapters two and three to maximize your time and your materials. *Also*, read through the actual step-by-step demonstration and look at the pictures *before* you cut your stencils to determine how many stencils a drawing needs to ensure your success.

As with any reference illustration, many of the colors you see used in the step-by-step demonstrations are variable. While black should usually be used for drop shadows and many lettering styles, you can use colors according to your own taste for other portions of the projects in chapters three and four.

## Airbrushing Shape, Shading and Highlight Stencil

(see page 31)

## Using Overspray to Blend Colors Stencil
(see pages 32-33)

## Gradating Color to Create a 3-D Effect Stencil
(see pages 34-35)

Cut two stencils: One is a negative stencil for
the heart shape itself, and one is a negative
stencil for the highlights only (the heart shape
is a positive stencil here).

**Airbrushing Stenciled Script Lettering Stencil**

(see pages 36-37)

Reuse the stencils you cut for the previous
project or cut new ones.

## Rendering Dimension and Form Stencils

(see pages 38-40)

Cut two stencils: one negative stencil for the whole broken heart (the space between the halves is not cut out) and the arrowhead and feathers, and one negative stencil for the highlights and the arrow shaft.

**Working With Intricate Stencils**

(see pages 41-45)

Cut three stencils. The first is for all the black areas—the detailing on the tiger and the words *IRONTON* and *TIGERS* ; in other words, all the areas of the tiger that are black on this artwork will be cut out. The second is for the orange areas of the tiger and the word *FIGHTING* ; in other words, all of the tiger *but* the black areas will be cut out. The third is for the detail areas of the tiger's face. These are the white highlights.

**Combining Lettering and Illustration Stencils** (see pages 46-49)

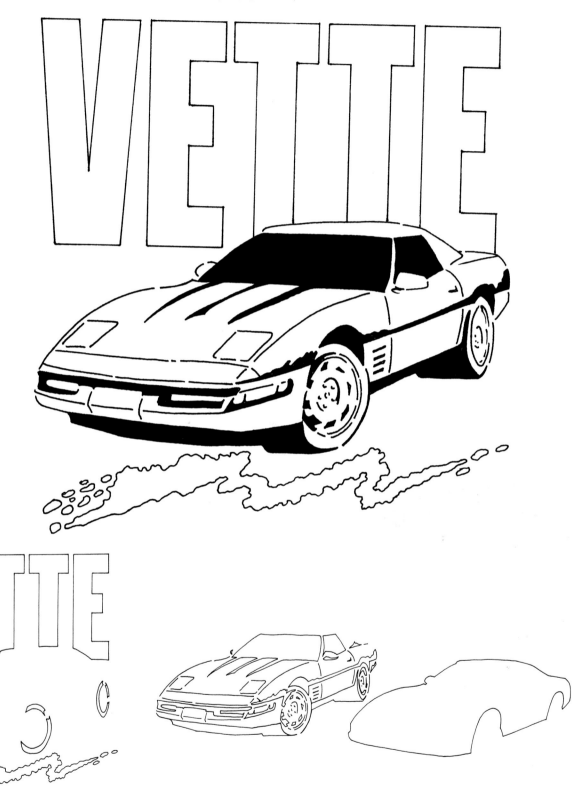

Cut three stencils. The first is for the word *VETTE*, the squiggle and the tires. The second is a negative stencil for the car shadow detail—the car body areas are a positive stencil—and the third is for the car body.

## Airbrushing Detail, Flesh Tones and Drop Shadows Stencils

(see pages 50-53)

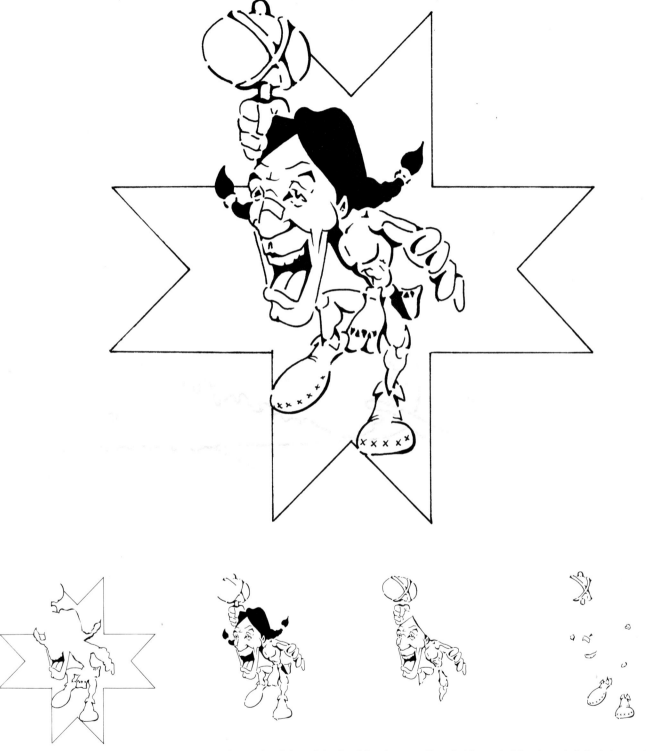

Cut four stencils. Cut a negative stencil for the background and the red details of the character. Note that the rest of the character's body is a positive stencil area. The second stencil includes all the detail areas of the character and the tomahawk. The third stencil is for the body and face of the character and the tomahawk. The last stencil is for the moccasins and some other small detail areas; look closely at the illustration for step eleven before cutting.

## Using Multiple Stencils

(see pages 54-57)

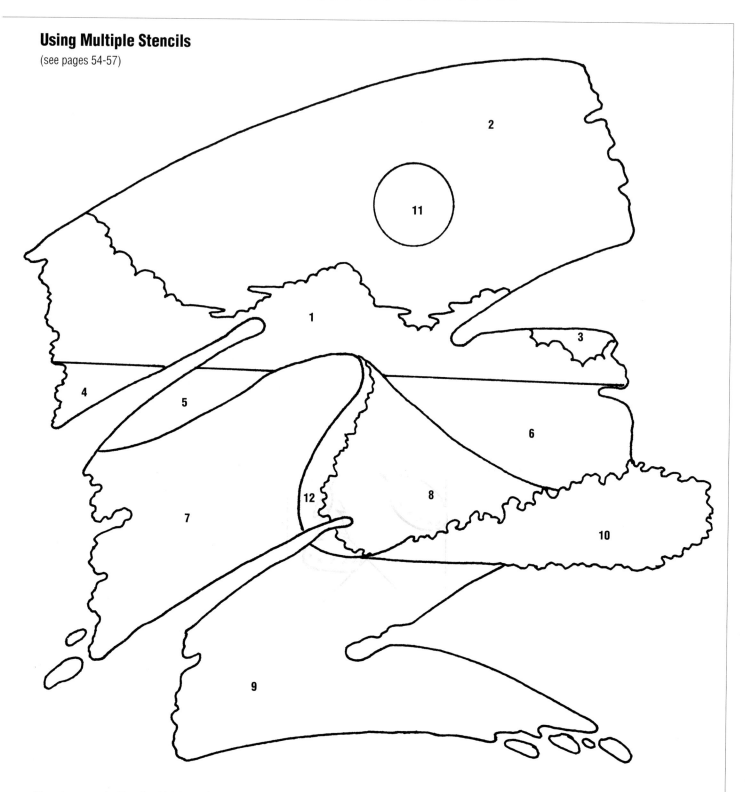

There is one main stencil, which is cut into twelve pieces to fit together like a puzzle.

## Combining Multiple Lettering Styles Stencils
(see pages 58-61)

Cut three stencils: one for the word *HEAVY*, one for the drop shadow for *HEAVY*, and one for the word *METAL*. You'll also need to cut one straightedge stencil following the directions in step three.

# INDEX

FREE CATALOG OFFER: North Light Books publishes instructional books for artists, crafters, illustrators and designers. For a FREE catalog, write to North Light Books, 1507 Dana Avenue, Cincinnati, OH 45207, or call toll-free 1-800-289-0963.